Sierra

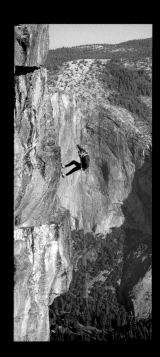

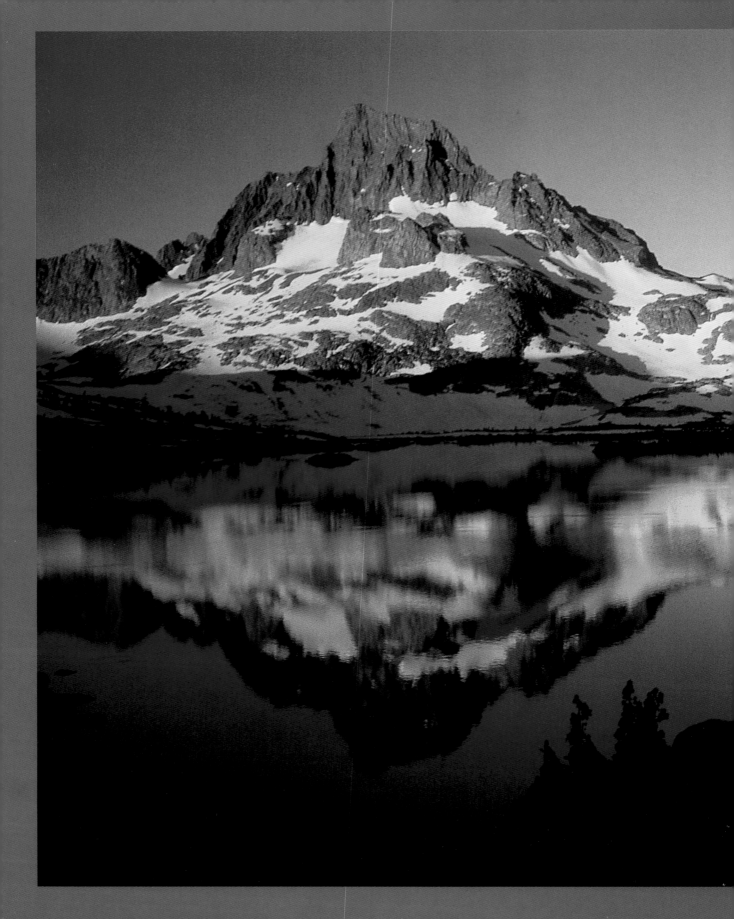

Sierra

Notes and Images from the Range of Light

James Martin

SASQUATCH BOOKS
SEATTLE

Important Disclaimer: Please use common sense. This is not a guidebook, nor a substitute for careful planning and appropriate training. There is inherent danger in all mountain activities and in the trails, climbs, and other routes and locations described in this book. Readers must assume responsibility for their own actions and safety. The author and publisher will not be responsible or liable for your safety or the consequences of reading this book.

Published by Sasquatch Books
Printed in Singapore by Star Standard Industries Pte Ltd.
Distributed by Publishers Group West
08 07 06 05 04 03 02 6 5 4 3 2 1

Photo captions: Page 1: *A climber rappels down a cliff in Yosemite with the east buttress of El Capitan in the background.* **Pages 2–3:** *Banner Peak reflects morning light in Thousand Island Lake.* **Right:** *Pines high on the Bighorn Plateau cling to life in the rocky soil.* **Page 7:** *The setting sun highlights the Minarets south of Yosemite (top); to ascend Reeds District in Yosemite, a climber must place a hand in the crack and twist it (lower left); the sheer east face of Mount Whitney dwarfs the rocky Alabama Hills in Owens Valley (lower right).*

Book design by Karen Schober
Map illustration by Jane Shasky
Copy editing by Don Graydon

Library of Congress Cataloging-in-Publication Data
Martin, James, 1950-
 Sierra : notes and images from the range of light / James Martin.
 p. cm.
 ISBN 1-57061-268-4 (pbk.)
 1. Sierra Nevada (Calif. and Nev.)—Pictorial works. 2. Sierra Nevada (Calif. and Nev.)—Description and travel. I. Title.

 F868.S5 M375 2002
 979.4'4—dc21 2002066809

Sasquatch Books
615 Second Avenue
Seattle, Washington 98104
(206) 467-4300
books@SasquatchBooks.com
www.SasquatchBooks.com

For Greg Thompson,
always in the mountains.

—J. M.

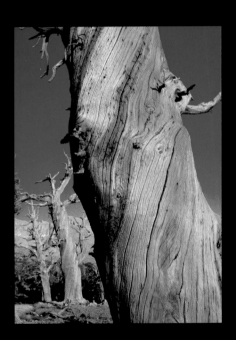

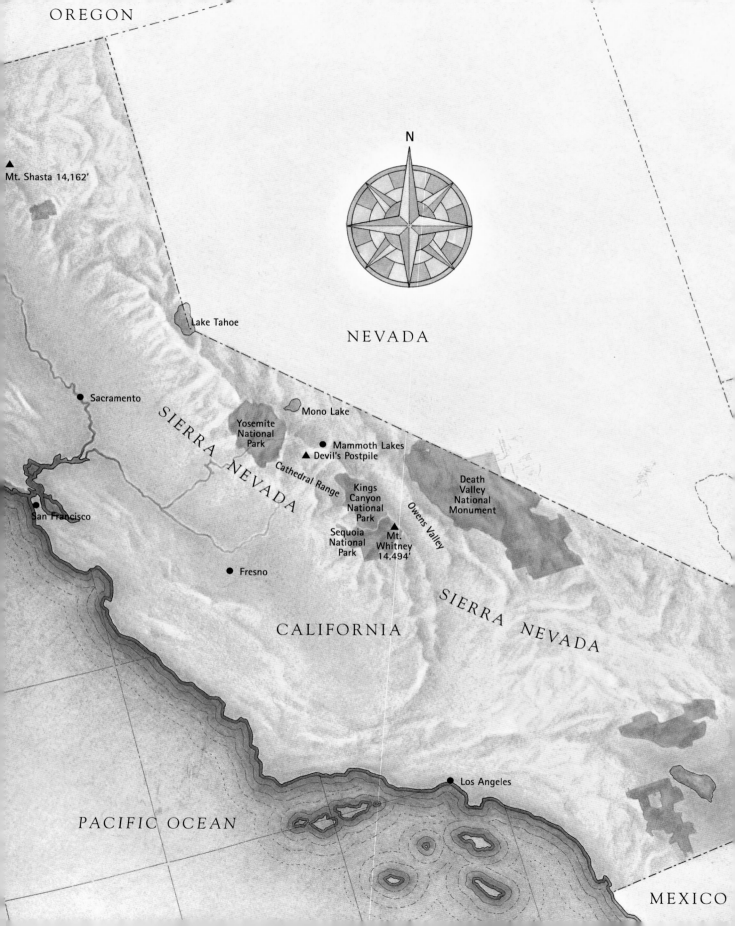

OREGON

▲
Mt. Shasta 14,162'

N

NEVADA

Lake Tahoe

● Sacramento

Mono Lake

SIERRA NEVADA

Yosemite
National
Park

● Mammoth Lakes
▲ Devil's Postpile

Cathedral Range

Death
Valley
National
Monument

Kings
Canyon
National
Park

Owens Valley

● San Francisco

Sequoia
National
Park

Mt.
Whitney
14,494'

● Fresno

CALIFORNIA

SIERRA NEVADA

● Los Angeles

PACIFIC OCEAN

MEXICO

Contents

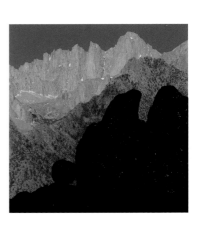

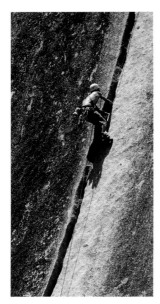

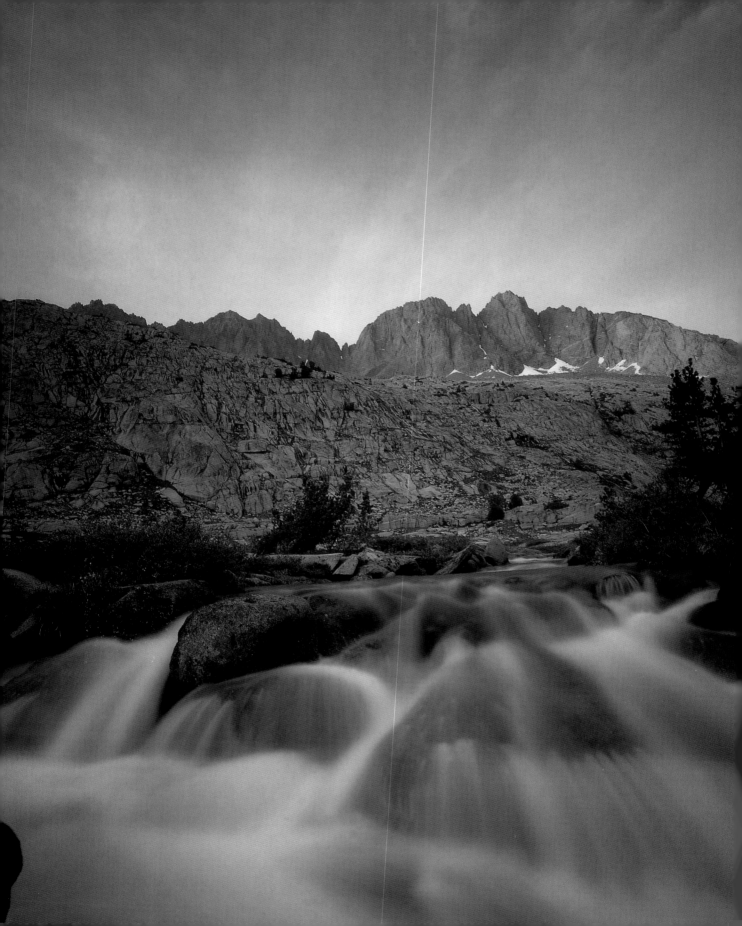

Introduction:
My Sierra

"The air seemed

to push me

softly backward."

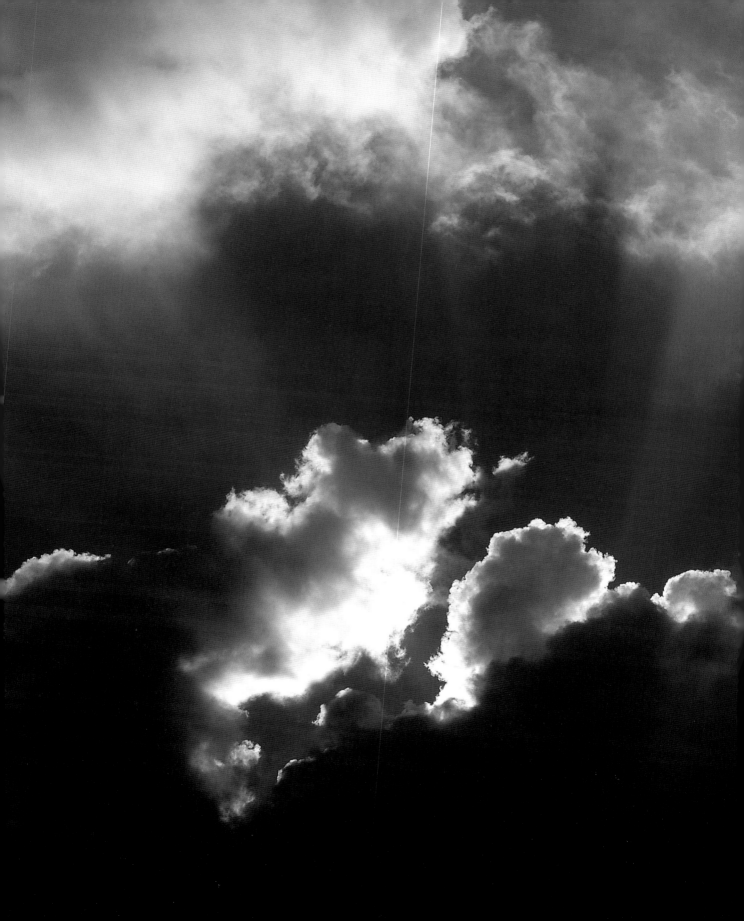

Introduction: My Sierra

Clouds piled against the peaks. We both knew we were in a race against a storm but said nothing. I hoped we could scramble the last thousand feet in an hour and get off before it hit. We hopped up a long unstable boulder field, then fought through loose scree when the boulders gave out, each step gaining only a few inches. When we arrived at the summit, a gunmetal gray ceiling descending toward us had already obscured the summit of nearby North Palisade. We peered into the great cirque carved by the Palisade Glacier, where sheer walls topped by blades, turrets, and stepped pyramids of rock ringed the ice. The Evolution Group hulked to the north-

west. Mounts Whitney and Williamson, massive peaks reaching over 14,000 feet, hid under a blanket of cloud. Columns of rain swept the Black Divide, thunder grumbled and echoed in the distance, and the wind kicked up. The spires around us seemed to vibrate like tuning forks, and the wind whistled like a choir of piccolos. Time to go.

We slid down the scree and skipped atop the boulders to conserve momentum. The slope soon eased so we could walk easily with long strides. My partner Roger DeCamp, known as the Bear because of his physique, pulled fifty yards ahead. The air smelled alive, and I suddenly felt the hair on my arms rise and my scalp tingle. I shouted "Lightning" and started to crouch when the sky in front of me erupted with light and a roar. The air seemed to push me softly backward. I sat quietly for a moment, listening to the walls shudder.

"Roger."

"Yeah."

"Close."

"Yeah."

"Let's haul ass."

"Yeah."

We dashed downhill. I buzzed with adrenaline, exhilarated and a little frightened.

We skirted a boulder-bound lake and climbed over a low pass that returned us to the Palisades Lakes drainage. We passed by heather gardens, glowing bright green under the muted cloud-filtered light. By the time we returned to camp, sunlight punched through the clouds, scanning the Palisade crest like searchlights. After dusk we laid out our sleeping bags and watched isolated stars reveal themselves as the summer constellations, wheeling imperceptibly across the sky.

I was a seventeen-year-old kid when I raced the storm with the Bear, but I was already intoxicated by the range. It runs for 400 miles parallel to California's Pacific coastline between the great Central Valley and the desert of Owens Valley. The range rises gently from the west, but the eastern escarpment soars out of the desert with as much as two vertical miles of relief. Three national parks—Yosemite, Sequoia, and Kings Canyon—protect the highest country, including Mount Whitney, the tallest point in the

Right: *The East Face of Mount Whitney and the Keeler Needle attract climbers from around the world.*

Following page: *Fin Dome presides over 60 Lakes and Rae Lakes Basins.*

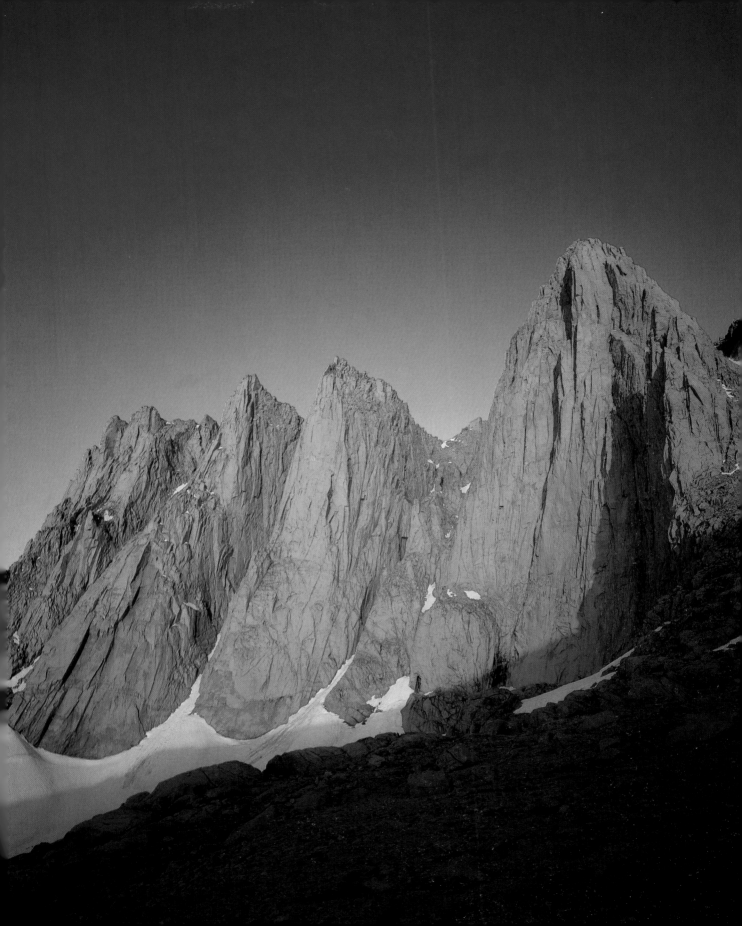

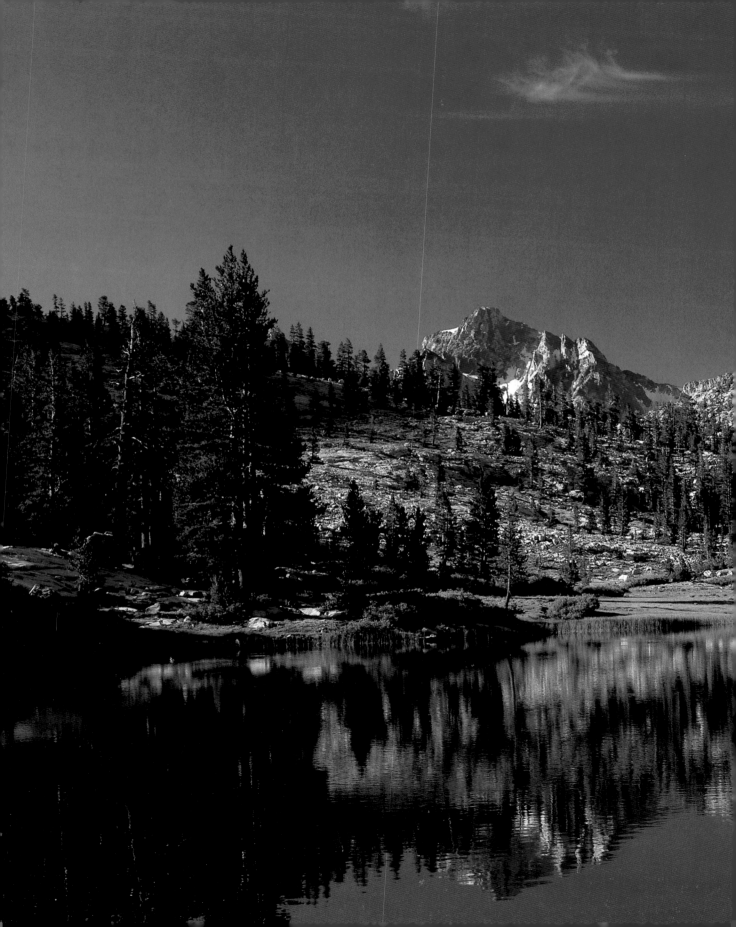

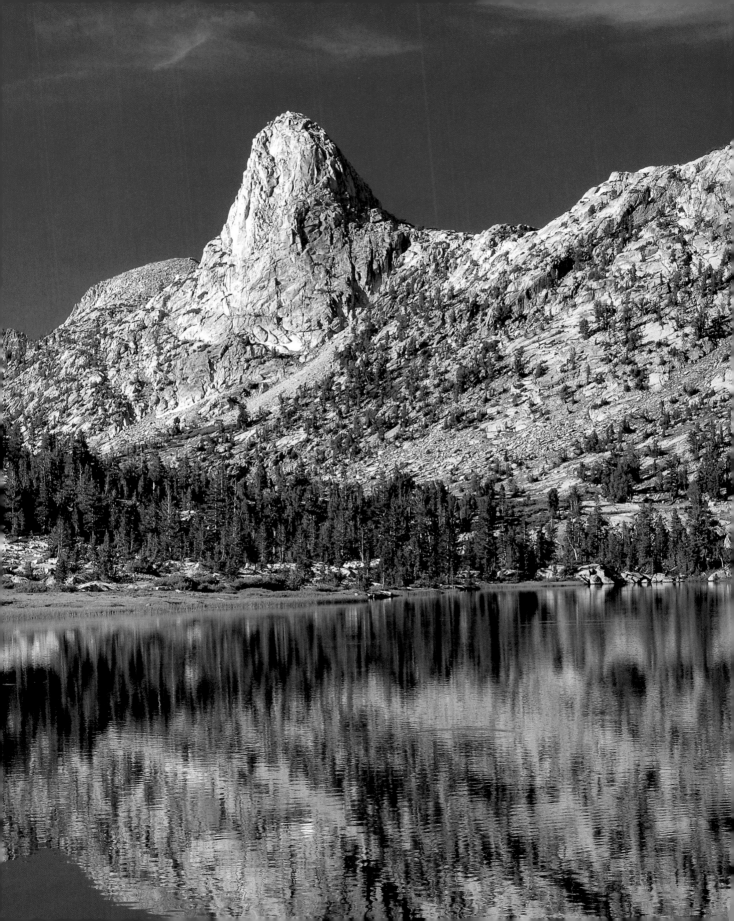

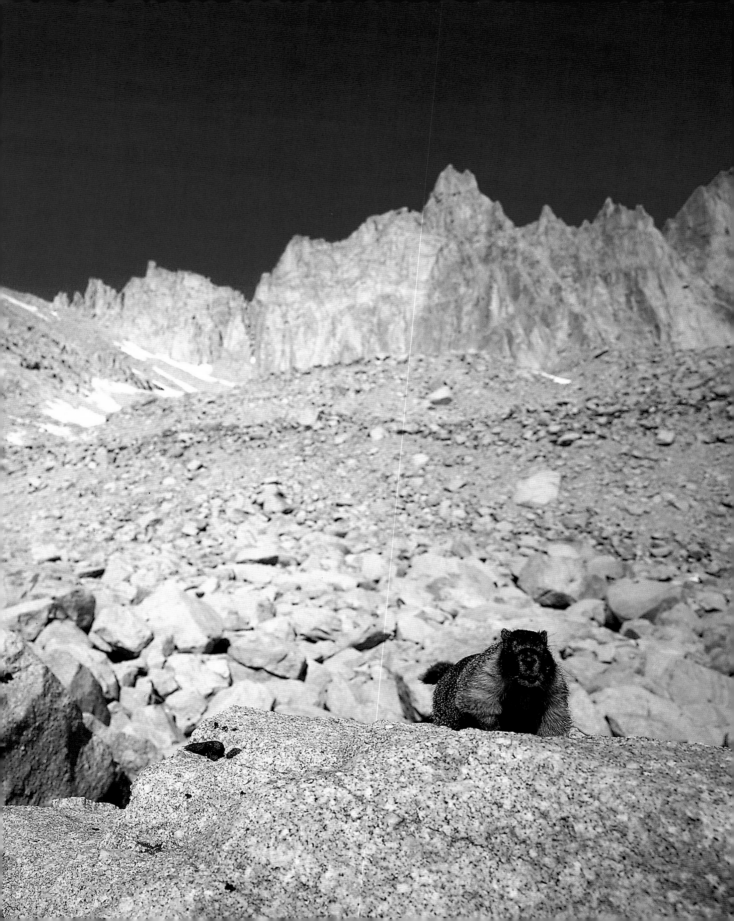

contiguous forty-eight states at 14,494 feet. Sun-drenched and glacier-scoured, the pale rock of the range shines, the lakes glitter, and the snow-fields glare during the warm summer days, proving that this is indeed the Range of Light as John Muir wrote more than a century ago.

I'm not sure what prepared me to respond so strongly to the Sierra. I had grown up in the San Francisco Bay Area, and by my mid-teens I was skinny, bookish, poor at team sports, and suffering from a mixture of arrogance and insecurity. In 1966 I was sent to a church camp in Colorado where I discovered that I felt fine at altitude and could enjoy the view from a 14,000-foot summit while many of my fellow campers fell behind or lost their lunches. Surprised at any sign of physical competence in myself, I decided to try hiking when I got home. During my preparations I was introduced to the writings of John Muir and Henry David Thoreau. Their message of finding salvation in wilderness struck a chord, impelling me to set out on my first wilderness adventures, first in the nearby Coast Range and later in the Sierra.

The year before my encounter with lightning, I visited the High Sierra in the company of a friend and his father. We hiked from Cedar Grove in Kings Canyon National Park to Charlotte Lake, a subalpine lake near the Muir Trail, following a creek through forest. We stopped a few miles short of the grand mountain scenery, but it was enough wildness to impress me. We encountered a mother bear, followed by two cubs, who asserted her right of way on the trail. For the first time in my life I fought deep fatigue for hours, as we made the hot ascent to the lake. Low-flying thunderstorms raked our camp. I acquired a few camping skills and heard stories of greater Sierra hikes. I had never felt so pleasantly isolated from people, which reminded me of the relief I experienced after leaving a noisy party. The hook was set.

I felt the need to "light out for the territories," so I organized a trip later that summer with two friends, Carl Cook and Bart Smith. We would hike out of Yosemite Valley to the headwaters of the Merced River and climb Mount Electra.

We started at the beginning of the John Muir Trail and followed it past Nevada Falls to Little Yosemite Valley. Here the Merced snaked placidly through forest, but eventually the canyon constricted and the route steepened. The trail climbed above the river and cut through domes of granite. The weather grew unsettled as we arrived at Merced Lake late the second day, but no rain fell and the sky cleared at dusk. We slept in the open under a canopy of stars.

Left: *Marmots forage for goodies in the high camp en route to Mount Whitney.*

Following page: *Mount Whitney catches last light as seen from the Bighorn Plateau on the John Muir Trail.*

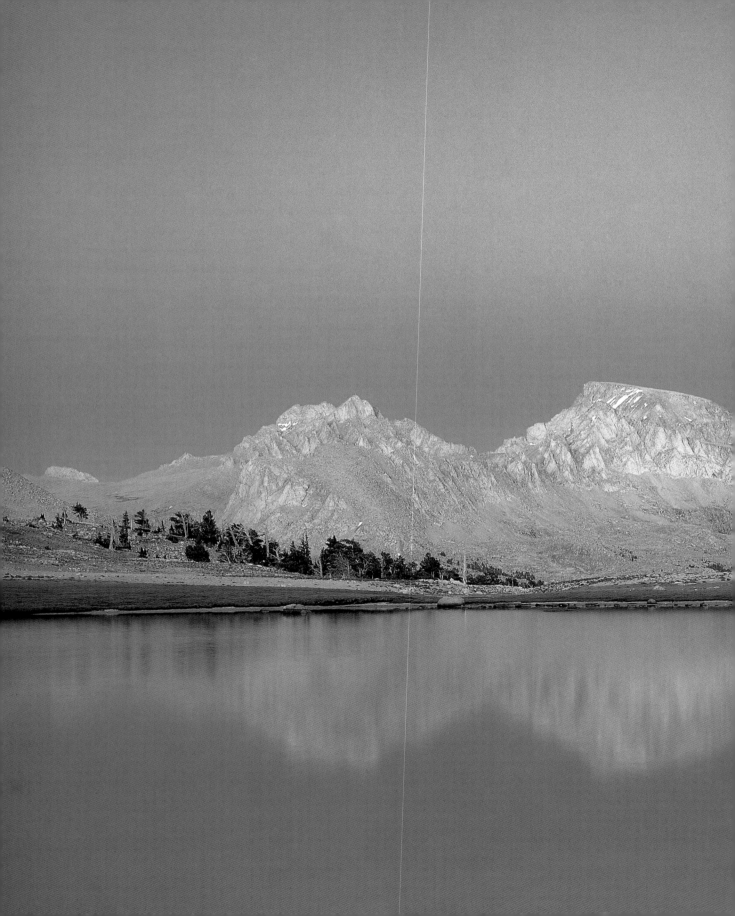

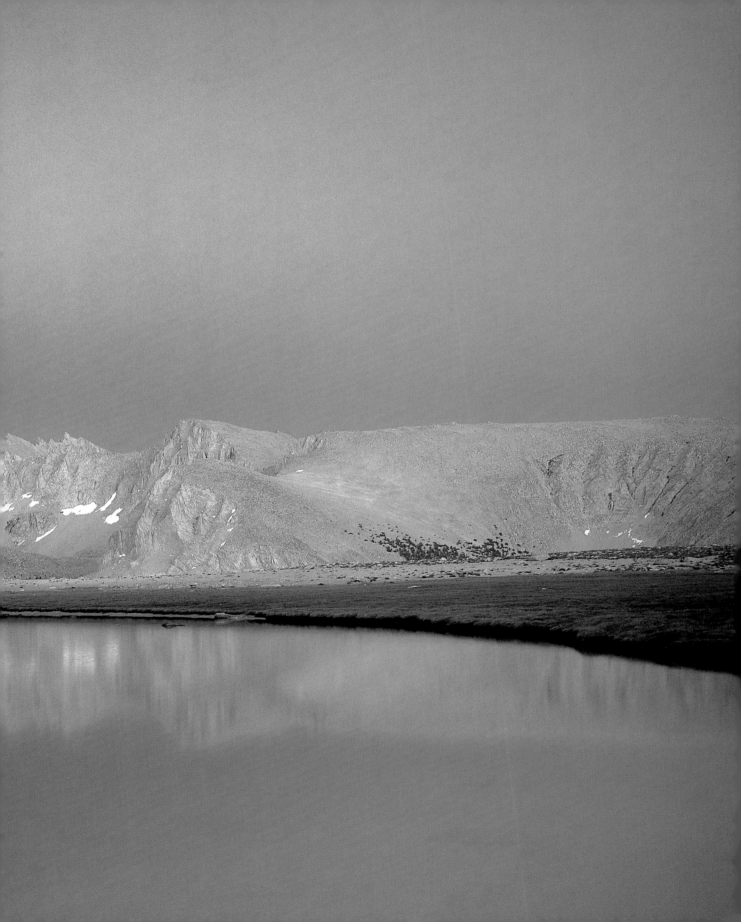

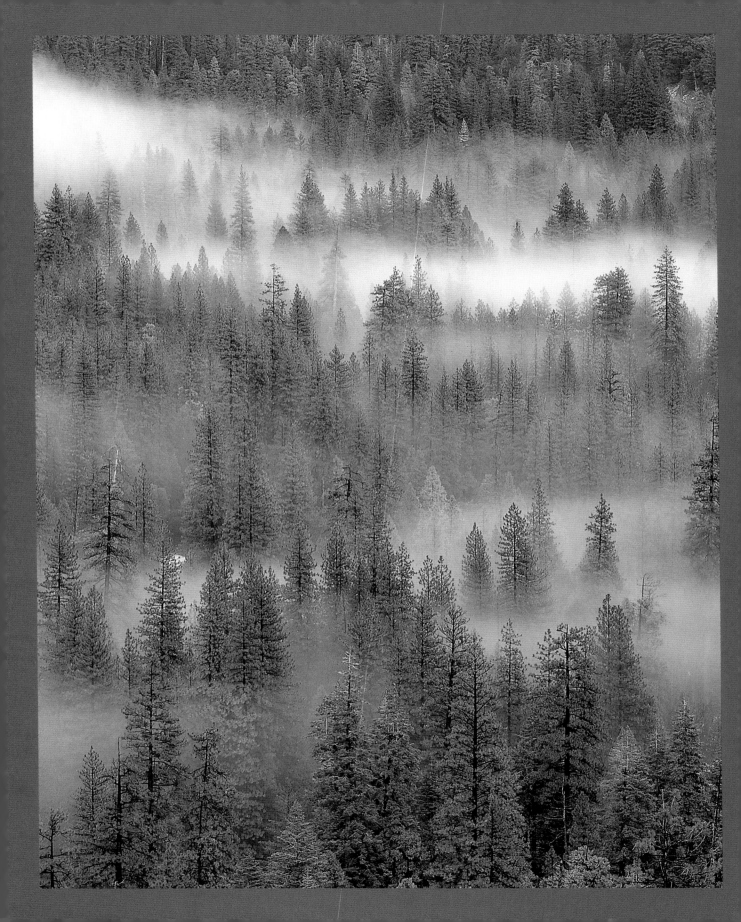

A snuffling noise woke me in the middle of the night. I looked over and saw a black bear inches away from Carl's face, sniffing. I tried to wake Bart with a stage-whispered "Bart, there's a bear," but he just mumbled and rolled over. I had no idea what to do. I slid out of my bag stealthily and then jumped up shouting, "Fuck you, bear!" The bear reared on its hind legs, twisted away from me, and disappeared into the night. I understand experts don't recommend this tactic. Naturalist John Muir tried a similar stunt early in his career. He rushed, shouting, at a black bear, which responded by standing upright and growling. Muir instantly regretted his ill manners and backed away.

From the lake our route switchbacked up the shoulder of the crest and then side-hilled south to a tributary flowing from Electra's basin. The route turned off the trail at the tributary, and we camped upstream. We worried about climbing the peak the next day when thunder and showers drifted through the area. Our concerns probably should have centered instead on our being ill-equipped, buck ignorant, and on our own.

That night Carl fell ill, so the next morning Bart and I headed up without him, beneath a sky full of puffy white clouds. We hiked through light brush and thin forest until we broke above tree line for the first time. Cascades slithered down polished granite, and the ponds known as tarns, ringed with talus, dotted the valley floor. The mountains, which appeared composed of solid rock from a distance, were clad in boulder fields and looked like heaps of rubble up close.

The puffy clouds had coalesced and seemed to reflect the dark gray of the granite. By the time we reached the base of Mount Electra, fat raindrops slapped the rock and stung our eyes. Wind tugged at our two-dollar plastic ponchos so our unprotected denim pant legs were soon soaked and our fingers felt fat, cold, and clumsy. Loose scree and large blocks that often shifted under our weight slowed us, so the rare intervals on solid rock were a relief.

Left: *Morning fog rises in Yosemite Valley in winter.*

We arrived at the summit in surprisingly dry conditions and added our names to the register. Blasted rock, tongues of ice on nearby slopes, and unnamed lakes gleaming like mercury surrounded us. Clouds roiled over the neighboring summits, while deep rumblings to the north sent a message even beginners could decode.

Bart and I hurried down the unstable talus. The wind gathered strength, and hail skittered on the rock, but the flush of success diverted our attention from the cold. By the time we reached easier ground, the wind had died, and showers grew to a steady rain.

Returning to camp, we found that the wind had blown the covers from our packs so our sleeping bags were soaking wet. After a dreary night shivering in damp cotton bags, our bedraggled party set off for Yosemite Valley at dawn, reeling in the trail as fast as we could, covering the three-day approach of twenty-five miles in one long march. Night caught us at Nevada Falls, but we stumbled the final miles in the dark to the parking lot, collapsing exhausted and happy.

Now the Sierra became an obsession. I read all of John Muir's published work and virtually memorized *Starr's Guide to the John Muir Trail*. Regional histories, climbers' tales, explorers' journals, and natural history books joined my library. I studied Colin Fletcher's *The Complete Walker*, which in retrospect led me astray by focusing on equipment over judgment. Thoreau's dictum "You are rich in proportion to the things you don't need" applies for backpackers.

From my reading and first forays to the Sierra high country, I began to understand the character of the range and to appreciate what a rare, lovely, and benign landscape it was. The white granite peaks seem to shine at noon, and they catch every warm tint at dawn and dusk. From the San Joaquin Valley the serrated mountains seem snow-covered even in late summer, which led the Spanish explorers to name them the Sierra Nevada, or snowy peaks. Below most high passes you will find long, verdant benches alive with white and red heathers and studded with alpine lakes. You can leave the trail behind and follow your nose across this open country. In summer, only the occasional thunderstorm darkens the sky in the afternoons, and the glum weeklong summertime drenchings of the Rocky Mountains and the Cascade Range seldom afflict the Sierra hiker. Among the mountains of the American West, only the Wind Rivers of Wyoming, a lower and shorter mountain chain, can rival the fine rock and open terrain of the Sierra.

Fortunately the federal government has protected the best of the High Sierra from development. Three national parks—Yosemite, Kings Canyon, and Sequoia—cover most of the land from the Sierra crest to the foothills over a north-to-south distance of almost two hundred miles. You can walk this high country end to end and cross only one road, the Tioga Pass route that bisects Yosemite National Park.

After my studies of the mountaineering literature, I planned a long trip

Right: *An afternoon breeze blows back mist on Bridalveil Falls in Yosemite Valley.*

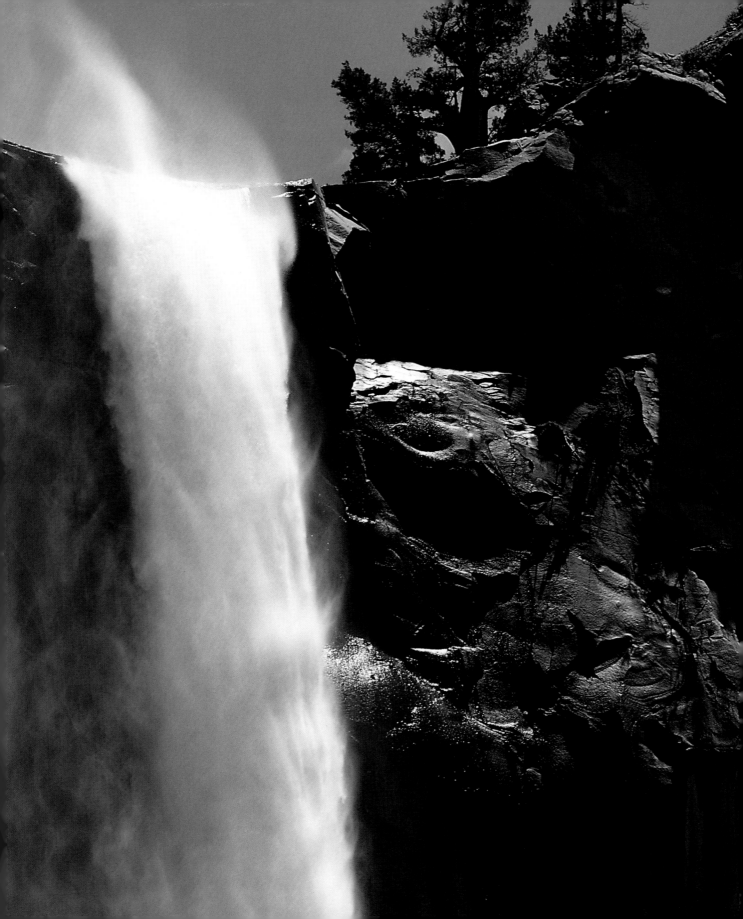

for the next summer combining the Muir Trail and High Sierra Trail, 350 miles in six weeks. Four friends including the Bear joined me. Only the Bear walked every mile. I dropped out for a week to let my blistered feet heal and rejoined him at Cedar Grove. Everyone else gave up and went home. We allotted three weeks for the remainder of the hike: Cedar Grove to the Middle Fork of the Kings River, up to the Palisades, down to Mount Whitney, and west to Giant Forest, 175 miles without resupply. We knew we would run out of food but figured we could bail out on an access trail or simply fast for a few days.

Before packing, I spread my gear out, a spartan kit, even for 1968: Kelty BB5 backpack with a thin unpadded hip belt, cotton sleeping bag, plastic tube tent, ensolite sleeping pad, aluminum pot, spoon, knife. Sunglasses, waxed matches, plastic poncho, Levi's jacket. Instamatic camera and three film cartridges. The seams of the Kelty strained with as much food as I could pack: rice, noodles, gorp, tuna, rolls, oatmeal, cocoa, salami, dried fruit. Slipping rubber pads over the simple nylon waist belts, the Bear and I hoisted our packs and felt the thin shoulder straps digging into flesh. An immense whale's back of granite separated us on the South Fork of the Kings River from the Middle Fork, six thousand vertical feet, up and over in twenty-eight miles. Morning sun heated the canyon. We labored on the south slope all day, trying not to count switchbacks.

The days grew easier, and we were often alone. The Bear scooped trout out of shallow streams with his bare hands to stretch our food supply. Solitude and effort hardened me, and days of monastic silence on the trail stripped away the concerns I considered important at home and the ways of seeing I took for granted. One day as I walked alone near sunset above our cold camp near Pinchot Pass, my internal chatterbox stopped and my senses operated unedited. I saw the rocks glowing in a buttery light and felt the cold air, but I didn't comment to myself or try to hold on to it. I felt like a child reading for the first time when a word resolves itself from a hodge-podge of lines and curves to become a concept. The world flooded me and I had neither the ability nor the inclination to name anything. I had stumbled into a moment of quiet and clarity.

As we slowly ran out of food, the ways of civilization attracted us more forcefully. We imagined what we would eat when we returned home, writing our choices inside our copy of *Starr's Guide*. By the time we climbed Mount Whitney, we were down to bouillon cubes. Four days later we finally straggled to trail's end at Giant Forest. Along the way we quartered the cubes and

Right: *The Cathedral Rocks rise thousands of feet above the valley floor.*

Following page: *Rock formations in the Alabama Hills are silhouetted against the eastern escarpment of Mount Whitney.*

sucked on them, shared a bag of half-eaten dried peanut butter some hiker had abandoned, and wolfed pancakes the cooks at Bearpaw Meadow camp gave us. I returned home a gaunt 135-pound six-footer, while Roger lost forty pounds during the hike. His football coach was furious.

Mountains are indifferent to human concerns. Mountains work on you like wind on a desert tower, sanding off extraneous material to reveal the hidden form. They provide a stage where decisions matter and feedback is immediate. They challenge your ability to see what is in front of your face and your capacity to respond to beauty. The first time you fall in love with the mountains is like any first love. You shed your chrysalis and enter a new life.

This book is a personal view. I love the highest Sierra, so I didn't try to cover the range north of Yosemite National Park or any place far from the crest of the range. I concentrated only on the human history of most interest to me, focusing on climbers and explorers. I feel affection for the gleaming rock of the range, and the processes that fashioned it intrigue me, so I dwell on the geology of the Sierra. On every trip I gravitate to the high country, the austere terrain above tree line, the landscape of the John Muir Trail and its environs. In traveling the world, I have encountered nothing like it. The highest Sierra, although rugged, invites exploration. No tangled undergrowth, impenetrable forests, or dangerous glaciers bar your way. The sense of unencumbered freedom and beauty I first found in the Sierra became a necessity in my life, and for it I am grateful.

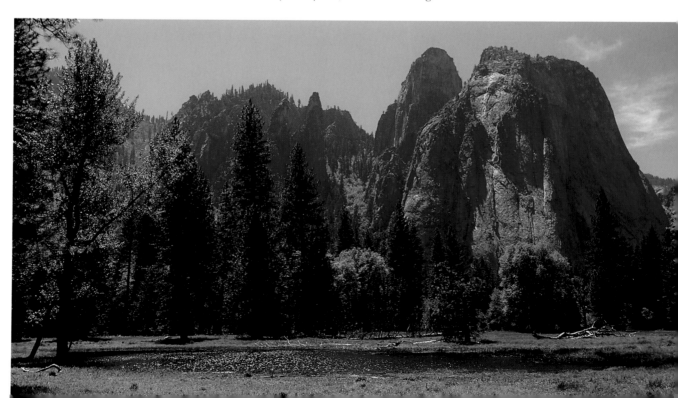

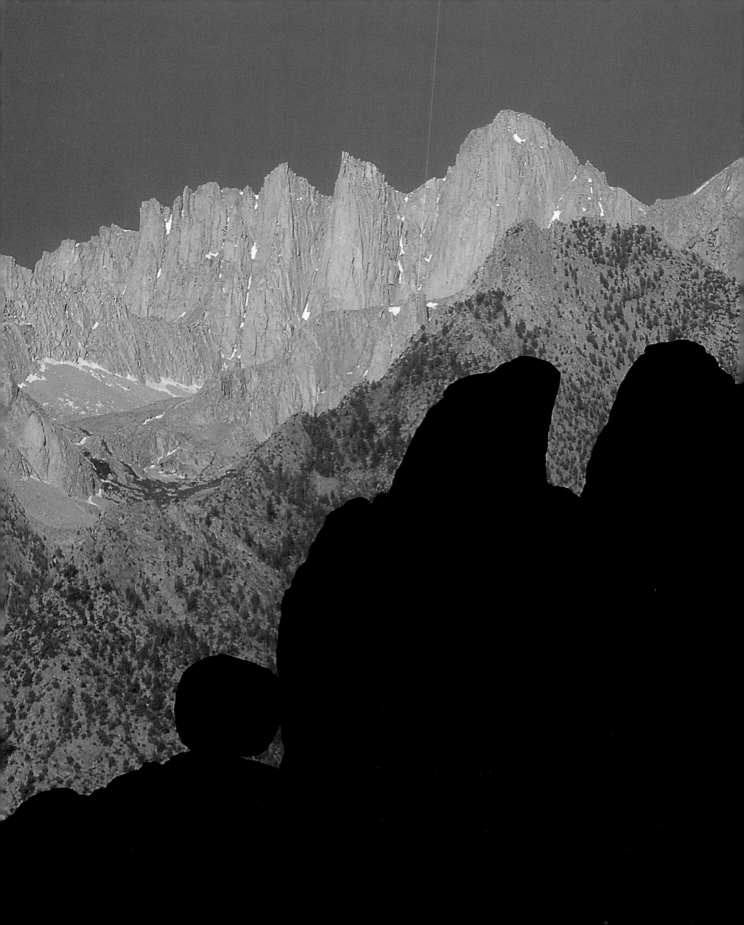

Rock

"The smell of burnt rock filled the air."

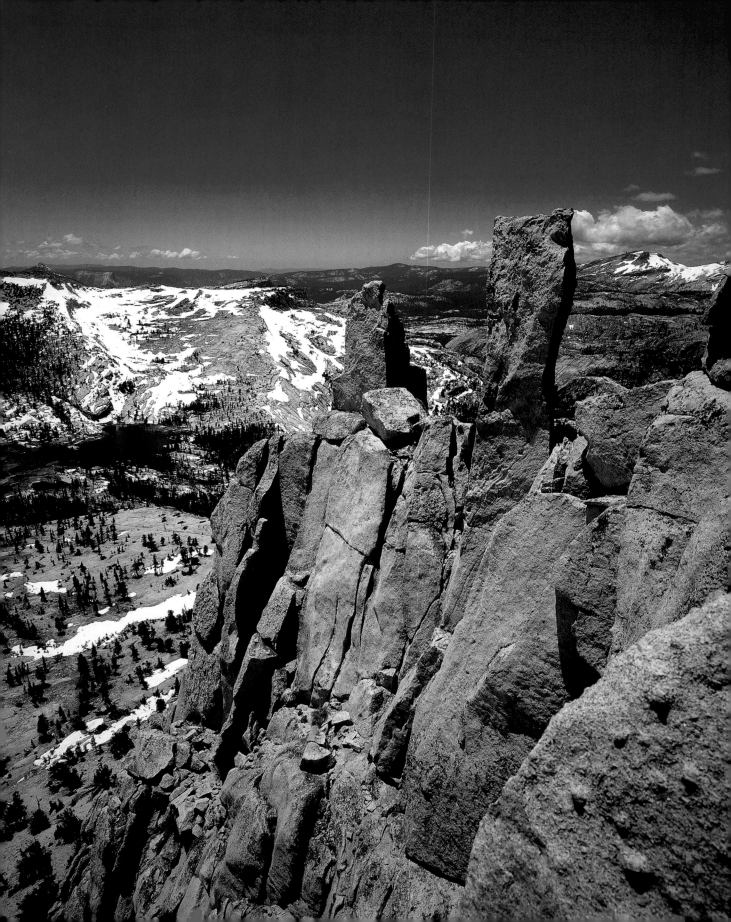

Rock

The morning sun reflecting on the white rock blinded me. I was climbing on chunky feldspar crystals embedded in the granite of Cathedral Peak in central Yosemite National Park. These jumbo crystals convert a steep wall into a climber's playground. Large handholds and footholds surrounded me. I moved confidently and easily without pausing much to place protective gear in the rock. A slip was unlikely—and also impermissible, since the sharp crystals would tear at me like a cheese grater if I came off.

I surmounted a vertical slot in the rock, known as a chimney, and placed protective gear to anchor myself at that spot. I called down to my wife,

Terrie, after pulling in the slack in the rope that connected us. She climbed quickly to the chimney and wriggled inside. As she grunted upward, two climbers appeared below her, moving rapidly. As they got closer, I could see they were traveling light. They wore nothing but climbing shoes.

The first climber placed his feet on either side of the chimney and grabbed crystals on the rock face with his hands to avoid squirming into the chimney, where the feldspar would abrade bare skin. He greeted Terrie with a cheery "Good morning" as he passed. Soon his partner sped past her as well. "This is the first nude ascent," he explained. She hoisted herself to the belay ledge and said "Nice view," while looking up.

We continued to the summit blocks and ascended the final exposed pitch. I tried to imagine John Muir in his leather boots soloing the first ascent here in 1868. I was grateful for the rope and my sticky rock shoes. From the summit the view extended to the boundaries of Yosemite in all directions. We could see the Sierra range tilting up from west to east. Most of the rock between the foothills and the summits was granitic, but the remnants of ancient volcanoes overlay the granite along parts of the crest. To the north we saw a sea of domes, to the east large blocky peaks, to the south another range paralleling the crest, and to the west deep U-shaped canyons, including Yosemite Valley itself.

Although the Sierra is a relatively young mountain range, the forces that created it started their work long ago. All the mountain building on earth, including the Sierra, is driven by movement of the immense oceanic and continental crustal plates that float atop a semiliquid layer of the earth's mantle.

The story of the Sierra began 215 million years ago as an oceanic plate collided with the North American Plate, forcing the heavier oceanic plate into a dive beneath the continental mass. For the next 135 million years, the force of this slow-motion collision melted rock and threw up volcanoes from Alaska to Mexico. Molten rock, known as magma, collected miles below the surface in pools that grew in size and eventually cooled and solidified to become vast *batholiths*, literally "deep rock." A batholith became the backbone of today's Sierra Nevada.

Eventually the ancient volcanic Sierra mountains began eroding faster than new eruptions could build them up. The remnants of the range filled the basin to the west, and the added weight pressed the earth's crust

Right: *Terrie Martin smiles near the top of Yosemite Falls.*

Following page: *The Palisades, including North Palisade, are the northernmost group of 14,000-foot peaks in the Sierra.*

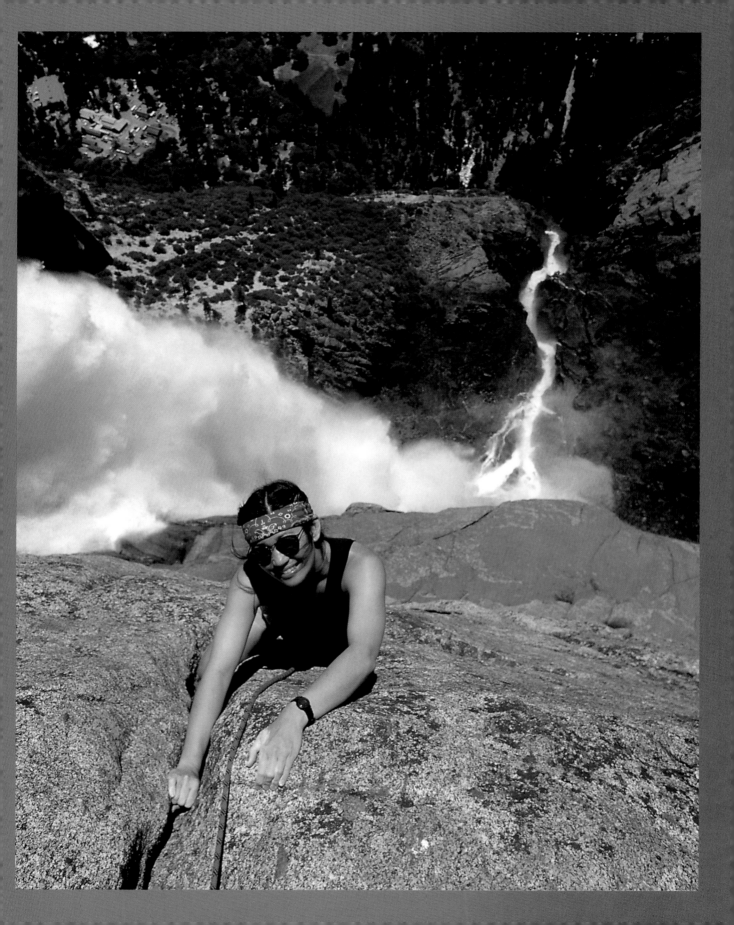

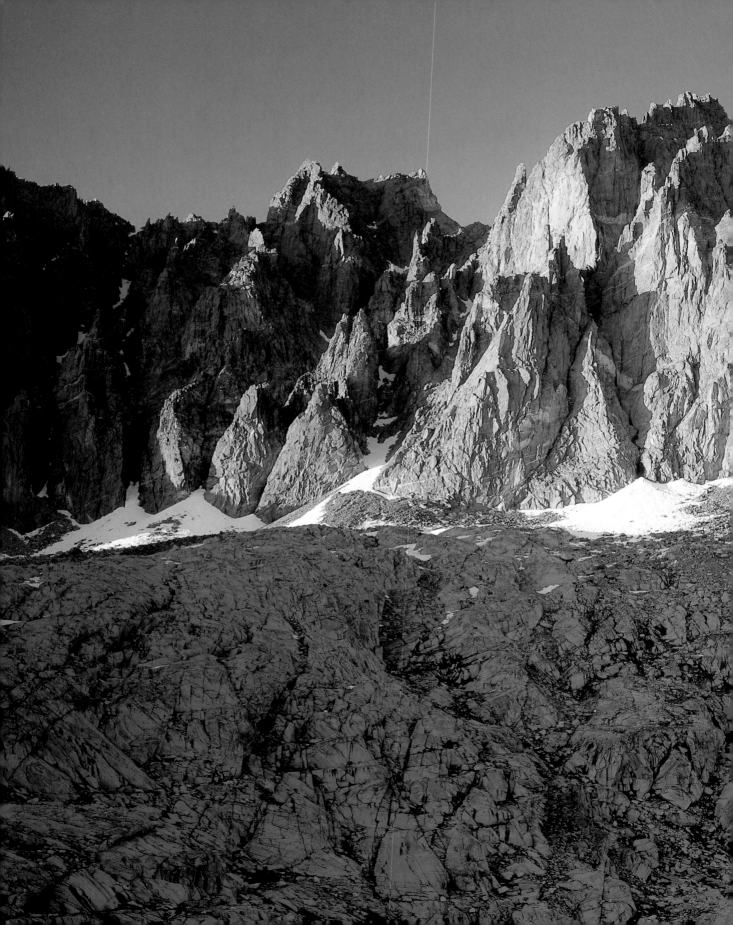

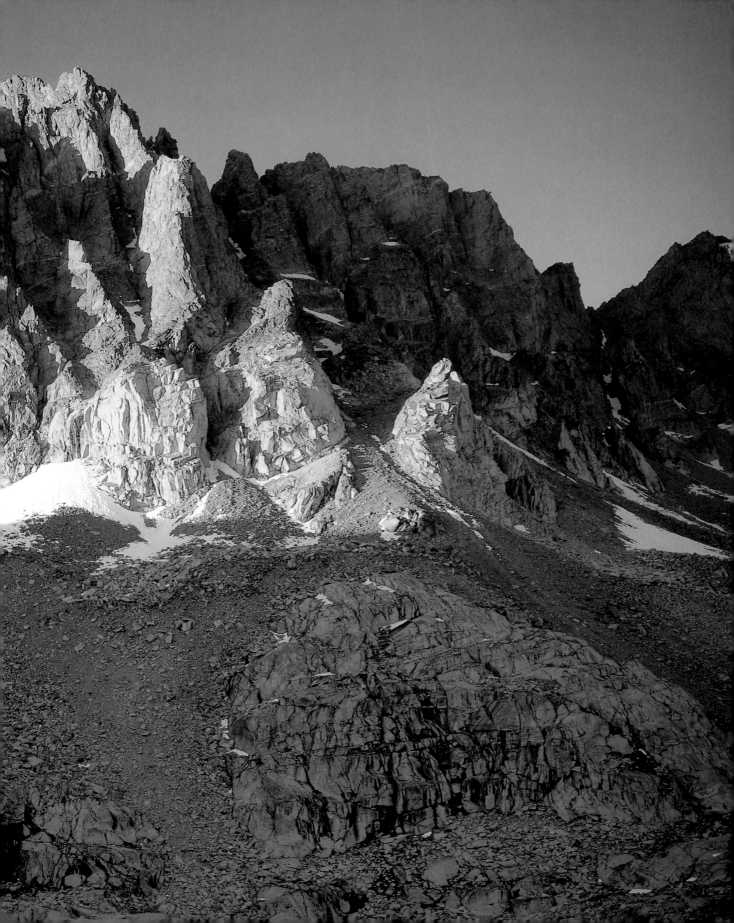

downward while at the same time the batholith exerted upward pressure. By the early Cenozoic Era, about 60 million years ago, a range once taller than the present Sierra was reduced to rolling foothills with bits of the batholith rock poking through in places. The tallest peaks still consisted of the original materials, predominantly volcanic rock now metamorphosed from the heat and pressure exerted by the emerging batholith. From Cathedral Peak we could see some of this material in the ruddy rock of Mount Dana and Mount Gibbs, above Tioga Pass.

Below: *Recent glaciation flattened the top of Devils Postpile, revealing its hexagonal shape.*

Right: *On DAFF (Dome Across from Fairview) Dome in Yosemite, erratics—boulders deposited by glaciers—rest atop granite riven with intrusions called dikes.*

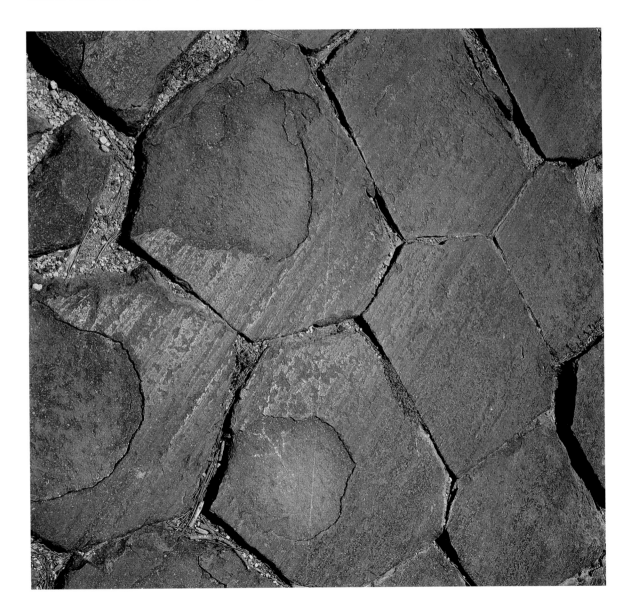

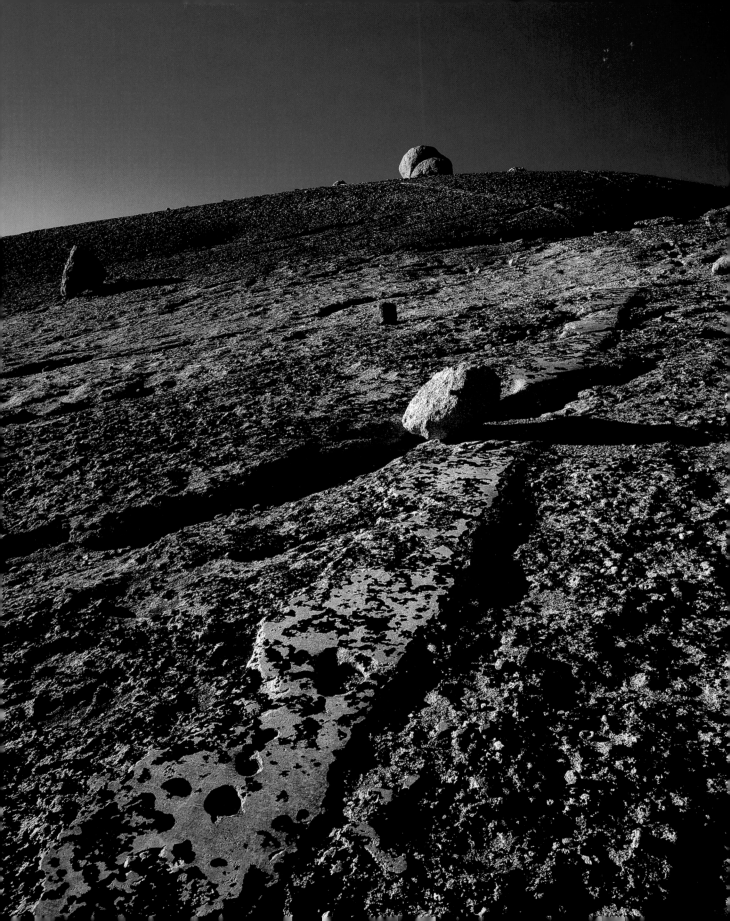

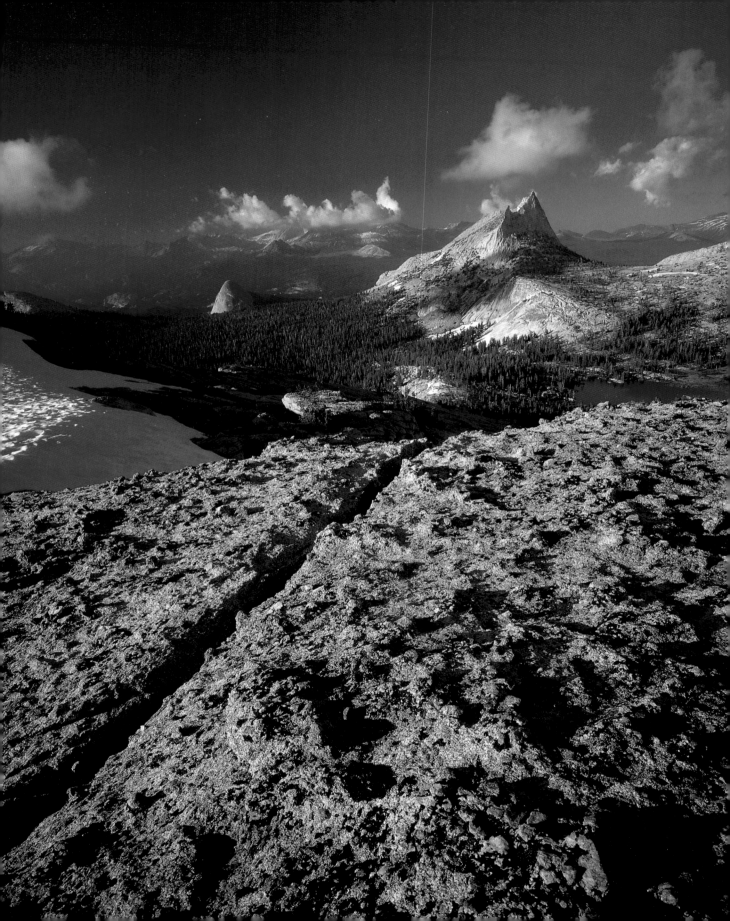

Left: *Cathedral Peak is composed of granite rich in large feldspar crystals.*

Below: *Bear Creek Spire is one of the highlights in the lonely country between Yosemite and Kings Canyon National Parks.*

Over millions of years, as the mass of the Sierran batholith grew, it sought to break through the crust even as it weighed it down. About ten million years ago the crust cracked on the eastern edge, allowing the range to thrust upward. At the same time, the sediments that had built up from the eroding ancient Sierra held down the western edge to create a uniform tilt, like a slab that is jacked up on one side. West of Mount Whitney in the southern Sierra, faults broke the uniformity, resulting in a parallel crest and trough, the Great Western Divide and the Kern River Canyon.

Three to four million years ago the rate of uplift increased markedly. Not only did the highest peaks grow higher, but the rate of erosion also increased. Rivers deepened the canyons of the Sierra. The Ice Age smothered the region in glaciers during the uplift, sending rivers of ice down the valleys, widening and deepening them into the landscape we see now.

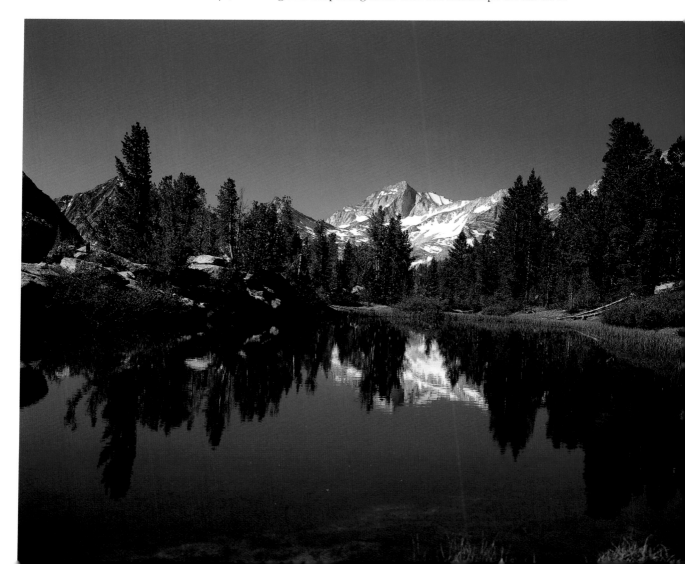

Domes are a characteristic and mysterious feature of Sierra topography. Granite often cools in flat sheets that can be uplifted and deformed later. As weathering works on the sheets, they tend to exfoliate like an onion shedding layers. While this may be the basis of dome formation, the precise mechanism remains unclear since other areas with similar geology don't develop domes in such profusion.

<p style="text-align:center">⟞⟝</p>

The Pacific crustal plate still tugs at the corner of California, and thus the Sierra Range continues to tilt ever higher while also sliding farther north. In historical times humans have felt the movement as earthquakes. In the Lone Pine quake of 1872, the earth shook as the range sprang up three feet higher and lurched twenty feet to the northwest in a few seconds. In the tiny town of Lone Pine on the eastern side of the Sierra, at least thirty people died.

The quake woke John Muir in Yosemite Valley, far to the north and on the other side of the Sierra. He dashed out of his bunk below Sentinel Rock into the moonlit night, shouting, "A noble earthquake." He was excited and nervous as the ground swelled like ocean waves beneath his feet. Eagle Rock, a freestanding pillar, disintegrated and tumbled into the valley as a luminous arc, lit by the friction of colliding rocks. Muir ran to the infant talus pile as the boulders settled with a grinding noise. The smell of burnt rock filled the air.

When major geologic faults slide above magma seas, they not only create earthquakes but also provide pathways for lava to reach the surface. Owens Valley on the eastern edge of the Sierra abounds with evidence of volcanic activity in the geologically recent past. Small cinder cones dot the landscape, and a great flow covers the terrain near the town of Bishop. Climbers play on small outcrops of volcanic tuff, while movie studios use the dramatic landscape for location shoots.

Ten thousand years ago a lava flow covered an area below today's Minarets near Yosemite. As the top of the flow cooled, the lava contracted, splitting into large columns. Further cooling induced more splitting. As the pool of warmer basalt below the surface cooled, it crystallized the same way, creating large columnar formations. The most famous example of columnar basalt is the Devil's Postpile west of Mammoth Mountain, an unusually straight and regular example of the process.

The sea of lava under the surface has tangible benefits. After a hard hike

Right: *Tufa formations in Mono Lake east of the crest were precipitated from minerals in the alkaline water.*

Following page: *While most of the Sierra consists of granitic rock, the older rock of the Minarets is composed of loose metamorphics.*

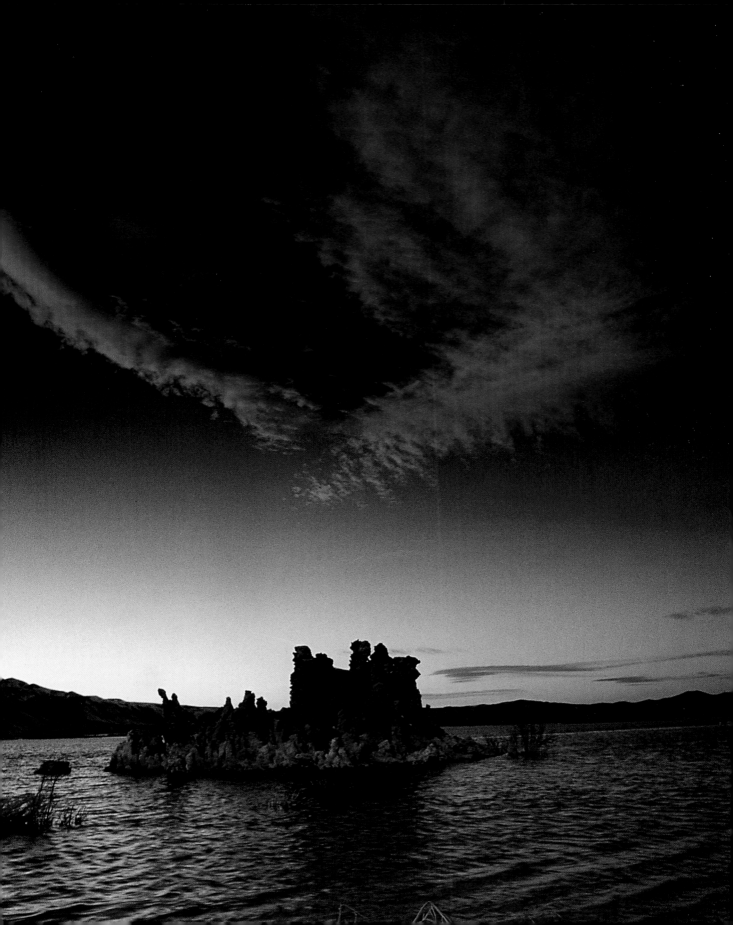

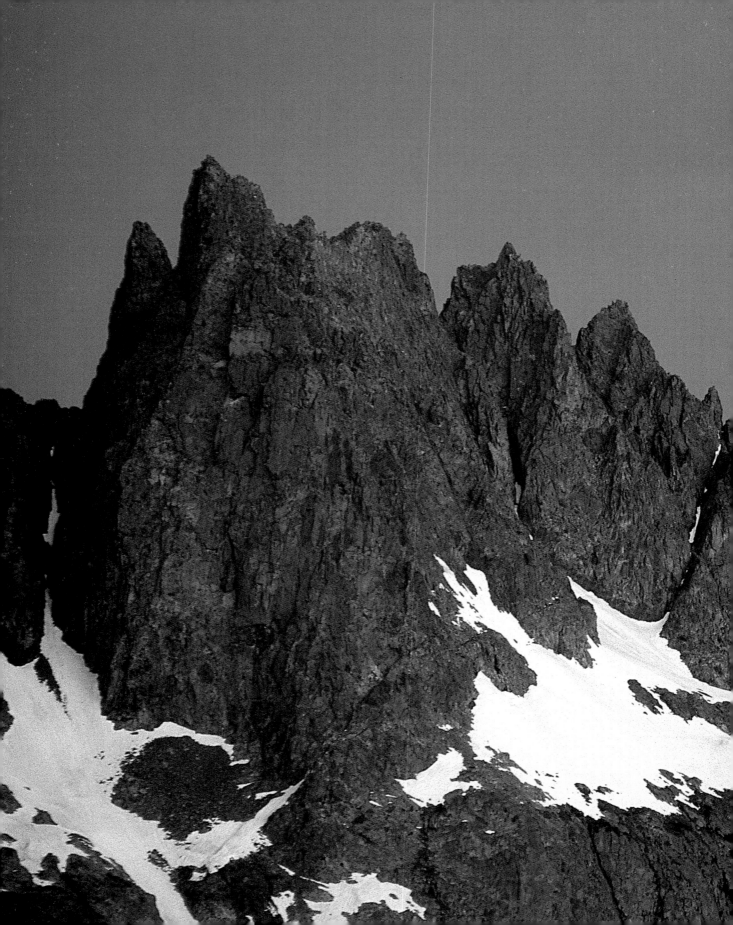

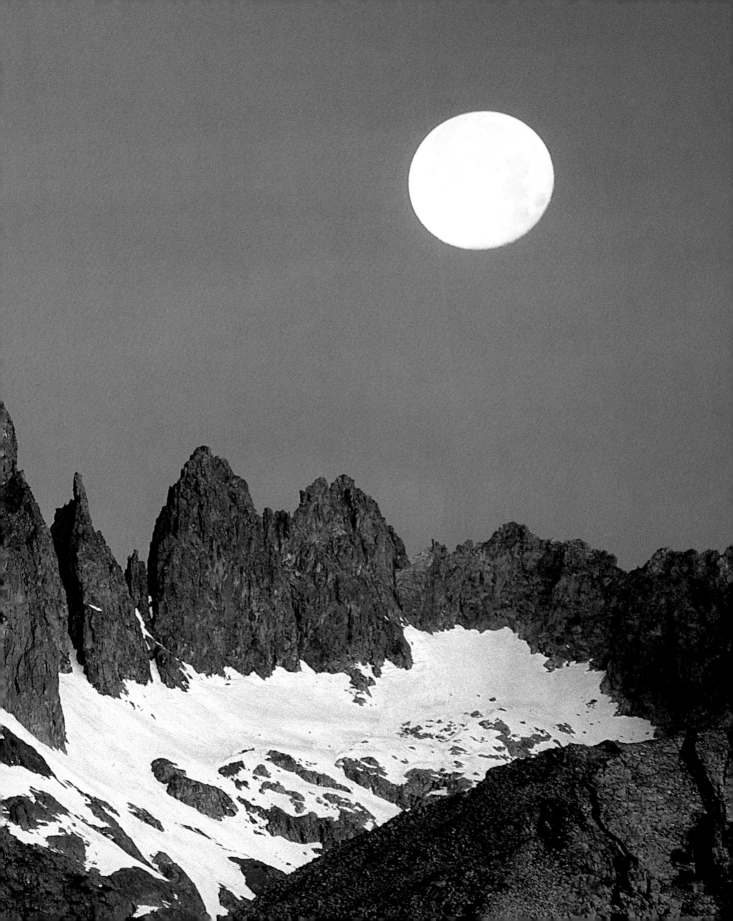

I often visit Hot Creek near Mammoth. Hot springs are created when groundwater comes in contact with hot rock. Here the springs reach the surface in the creek, and the mixture of hot water with the snowmelt of the creek allows you to find a perfect soaking temperature by moving about in the stream. But steer clear of the hottest water, and avoid fragile ground that could break through to a pool of boiling water. These days, authorities concentrate visitors in a relatively safe area, but the hot spots can move quickly, so the unlucky or incautious occasionally suffer serious burns.

The most violent volcanic event in the geologically recent Sierra history occurred south of Mono Lake about three-quarters of the way through the current uplift, some 760,000 years ago. A block of crust slid down on a magma chamber, creating tremendous pressure and triggering an explosive eruption larger than any experienced in recorded history. In 1980, Mount St. Helens blanketed Eastern Washington in ash when it erupted and ejected about one-quarter of a cubic kilometer of material into the sky. In comparison, the Sierra event shot 2,400 times as much material into the air, burying areas hundreds of miles away in ash and cooling global temperatures for years.

Magma is now returning to the area. A shallow dome near Mammoth Lakes has risen thirty-two inches in the last thirty years. The Mammoth area on the Sierra's eastern side experienced more than five thousand earthquakes in 1997, almost all too small to be felt by humans. Poisonous carbon dioxide releases have killed trees, and a cross-country skier succumbed to the fumes and died in 1998 near the town of Mammoth. Someday soon the magma in the Owens Valley will come to the surface, perhaps violently, although nothing of the scale of the great explosion appears imminent.

Geological processes are not merely part of the past. The Sierra mountains continue to grow higher even as erosion tears them down. We glimpse the earth in transition through a small window into deep time whenever we feel an earthquake or watch sediment carried downstream. If we are awake to these events, we can feel the excitement of John Muir in the earthquake, experiencing the earth creating itself.

Right: *Looking down Tenaya Canyon toward Half Dome in Yosemite.*

Following page: *Erratics and a lone pine on Olmstead Point in Yosemite.*

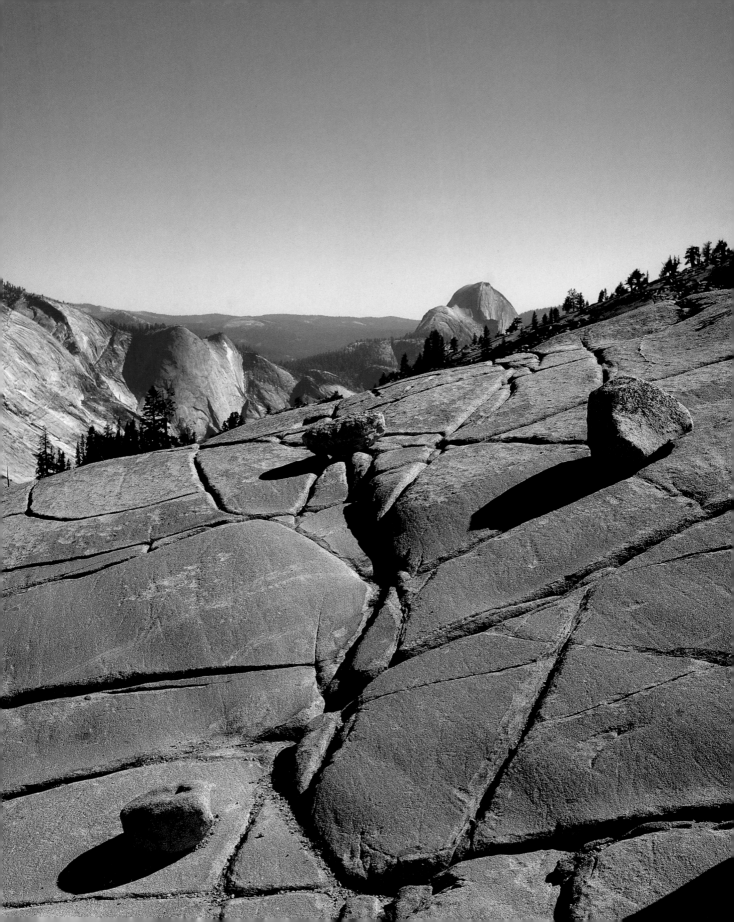

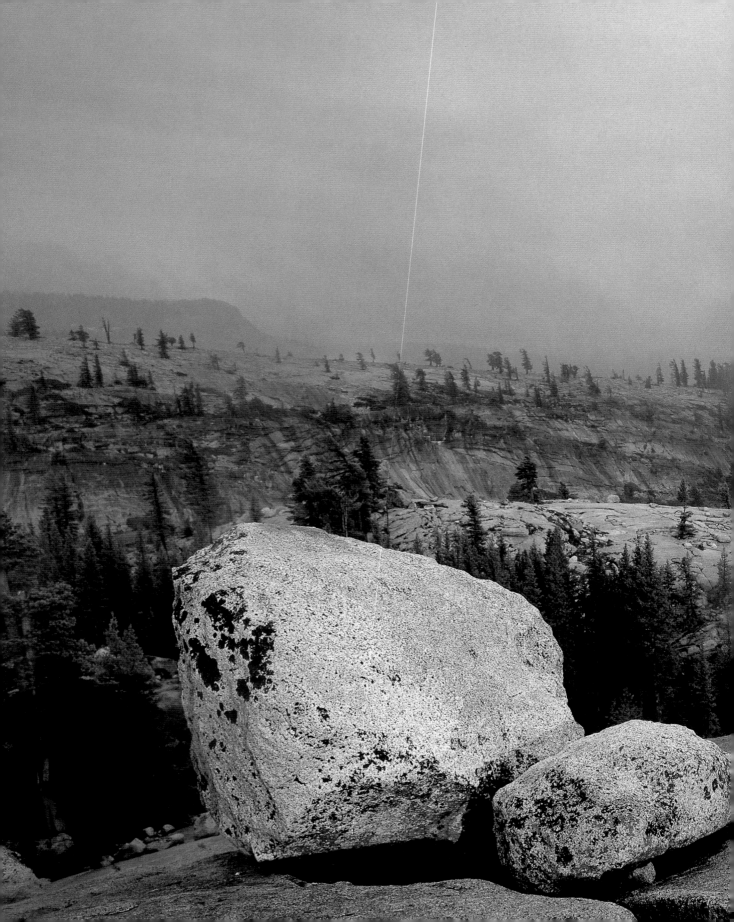

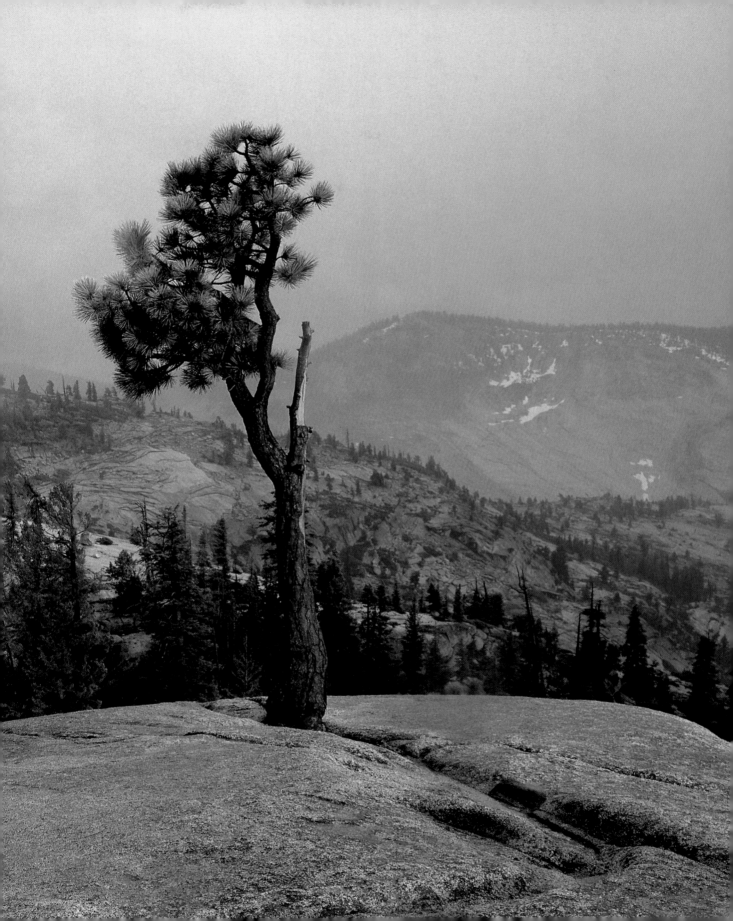

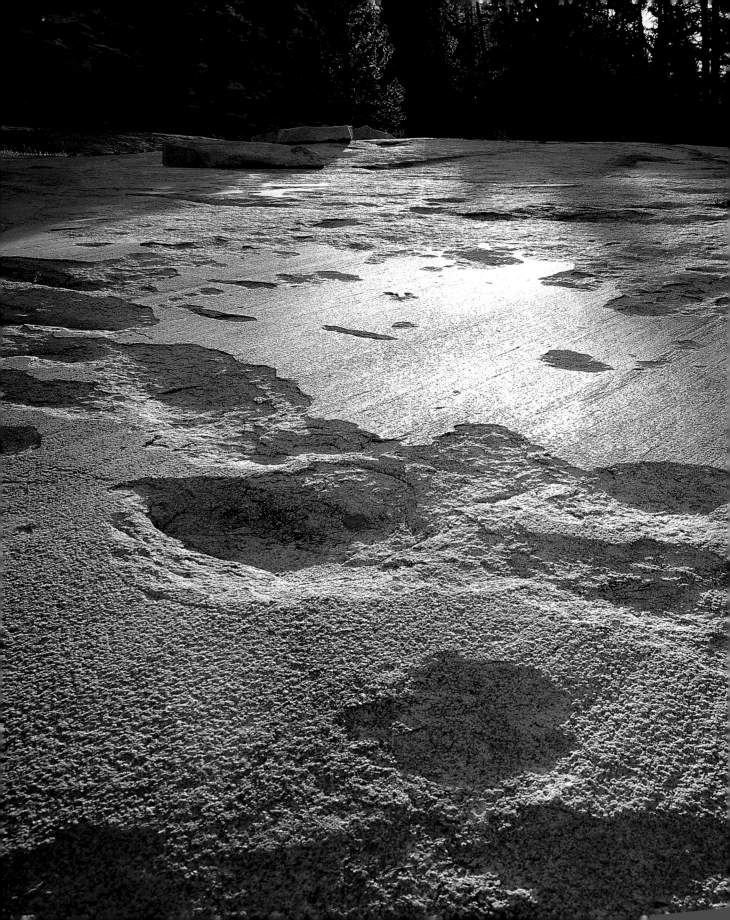

Ice

"...I swung the axe
hard overhead and the
ice shattered."

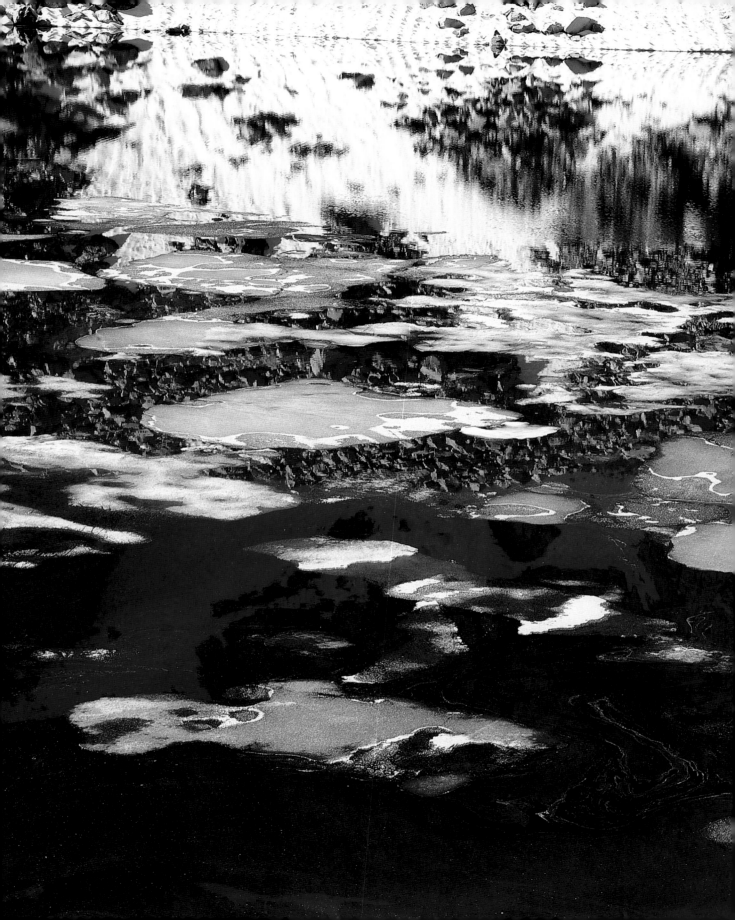

Ice

Three million years ago temperatures fell around the globe, initiating
the first major ice age since the end of the Paleozoic Era 225 million years
earlier. The nascent Sierra caught moisture from the Pacific and built a per-
petual snowpack. An ice cap developed, extending from the Feather River
in what is now Northern California south to the upper Kern River near
Mount Whitney in the southern Sierra. In places the ice thickened to four
thousand feet. Glaciers carved steep furrows along the eastern escarpment
and dug deep U-shaped trenches down the gentle western slope. These
trenches became the signature canyons of the Sierra: the Kings Canyon, the
Grand Canyon of the Tuolumne, and Yosemite Valley.

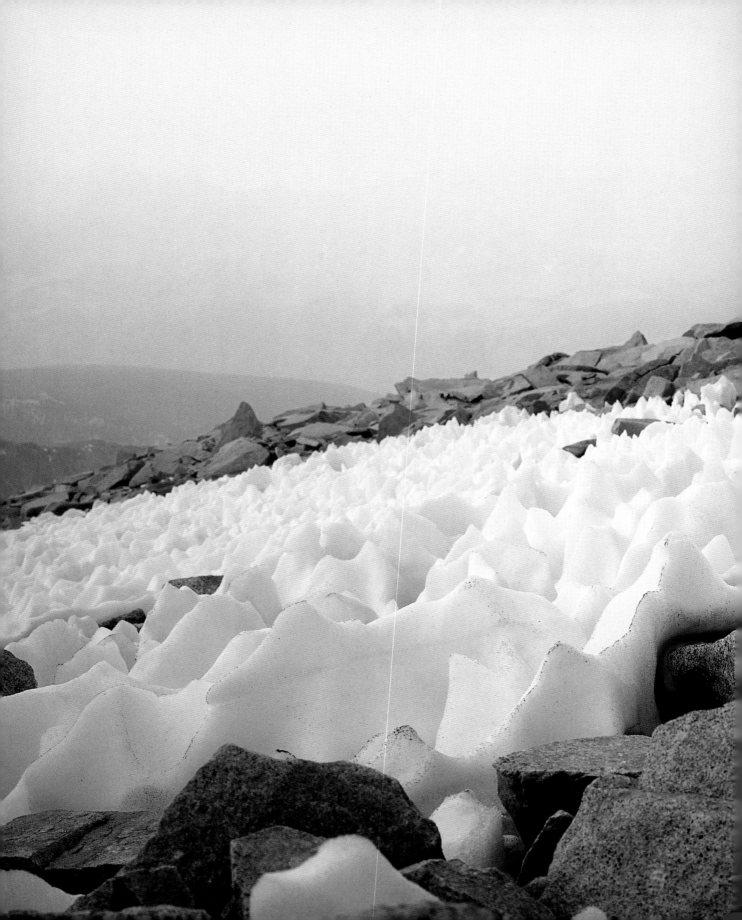

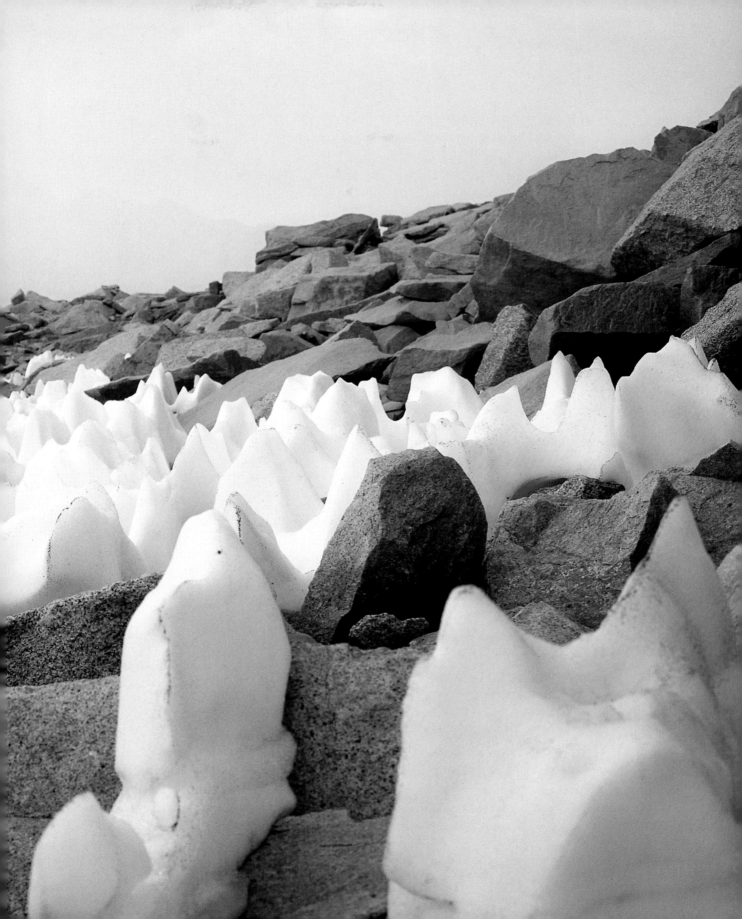

At the height of the glaciation, ice filled Yosemite Valley to the rim. Only the tops of Half Dome, Sentinel Dome, and El Capitan escaped unchanged. When the glaciers melted, the valley was deeper than today, but then a natural rock dam west of El Capitan created a lake. The lake filled with sediment, and the progression of lake to meadow to forest commenced. Soon the forest will invade the last of the meadows.

At least three major glacial surges fashioned a new landscape. At first the ice covered a high plateau of rolling hills. Each advance carved deeper valleys and sharper ridges. They stripped the domes of soil and irregularities. Each retreat revealed a new creation.

The glaciers retreated for good 10,000 to 15,000 years ago and melted away entirely by 5,000 B.C. Since then a warmer climate has prevailed with one exception. Around 1300 A.D. temperatures fell sufficiently for the glaciers to grow again. The rebirth lasted 450 years, and the small glaciers we find in the Sierra today are the vestiges of this Little Ice Age.

The final retreat of the great glaciers accelerated the tilting of the Sierra Range. The great weight of the ice had held the range down, so when the ice cap melted, the rock bobbed up to a greater height. At the same time, erosional material deposited by the glaciers in the foothills held the western slope down.

From the summit of Cathedral Peak in Yosemite National Park, every view speaks of the ice ages. Erratics, giant boulders deposited by receding ice, balance atop lofty domes. Glacier polish glints on smooth granite. If you descend to the polish, you can read the glacial scrimshaw, striations aligned with the glacier's path scraped out by rocks embedded in the moving ice. Rock debris called moraines that glaciers deposited on their margins display the extent of glacial surges. The fins and spires of the Cathedral Range in the Yosemite high country testify to the power of the ice. The glaciers never reached the summit of Cathedral Peak itself, instead quarrying the base, insinuating ice into the vertical jointing. I imagine Cathedral's summit 100,000 years ago, a lonely stone pole in a sea of white, with views of moraines embedded in the ice converging like tributaries where glaciers met at the head of Yosemite Valley and Tuolumne Canyon.

Josiah Whitney and his California Geological Survey visited the Tuolumne region in 1860. He recognized the evidence for massive glaciation—moraines, erratics, striations—but he concluded that the nearby Yosemite Valley was created in a cataclysm, not carved by glaciation. He proposed that the bottom slid down the valley's vertical fault lines.

Right: *The Merced River roars during the spring flood below the entrance to Yosemite Valley.*

Following page: *Looking north across lower Tuolumne Meadows toward Mount Conness in Yosemite National Park.*

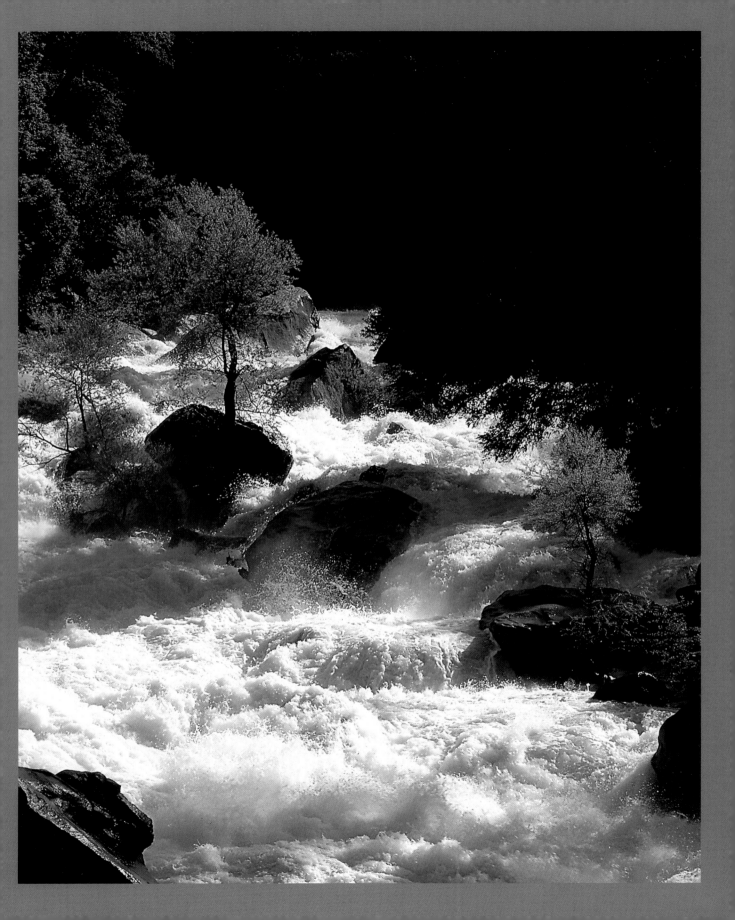

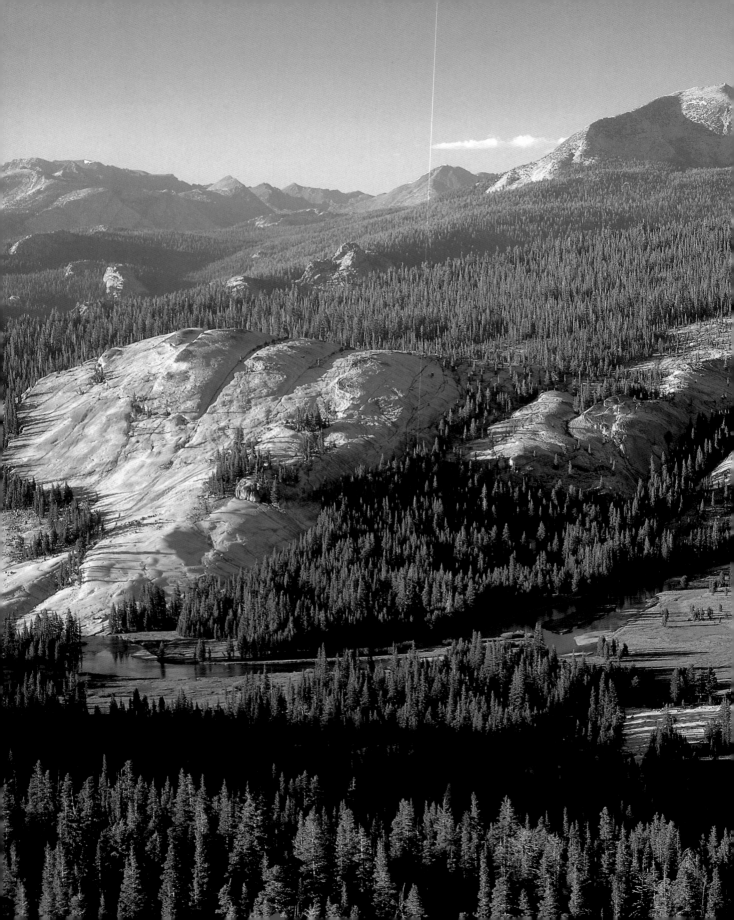

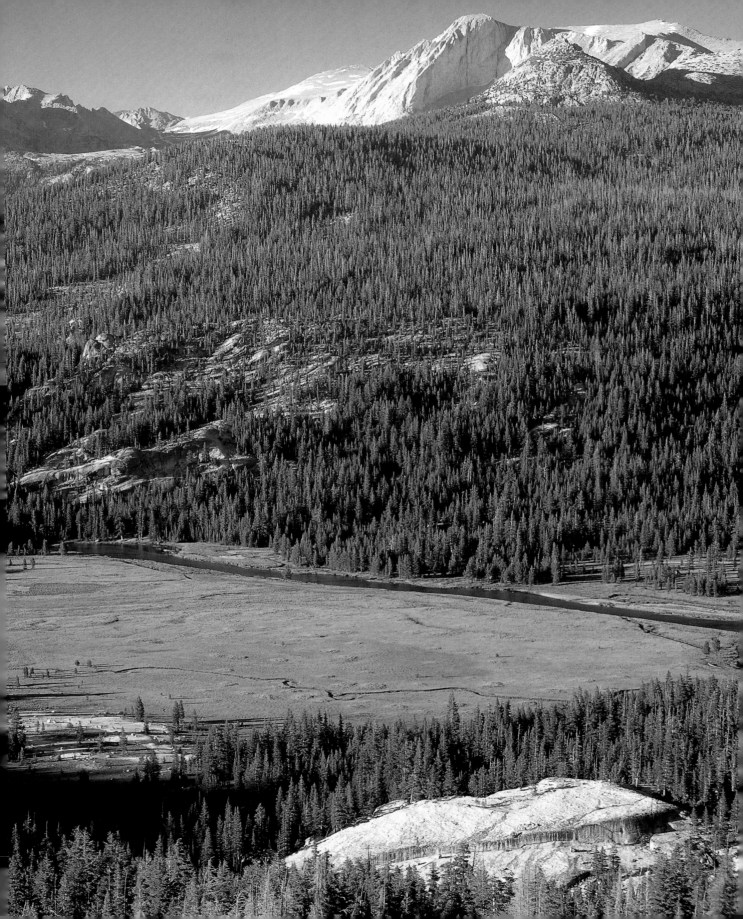

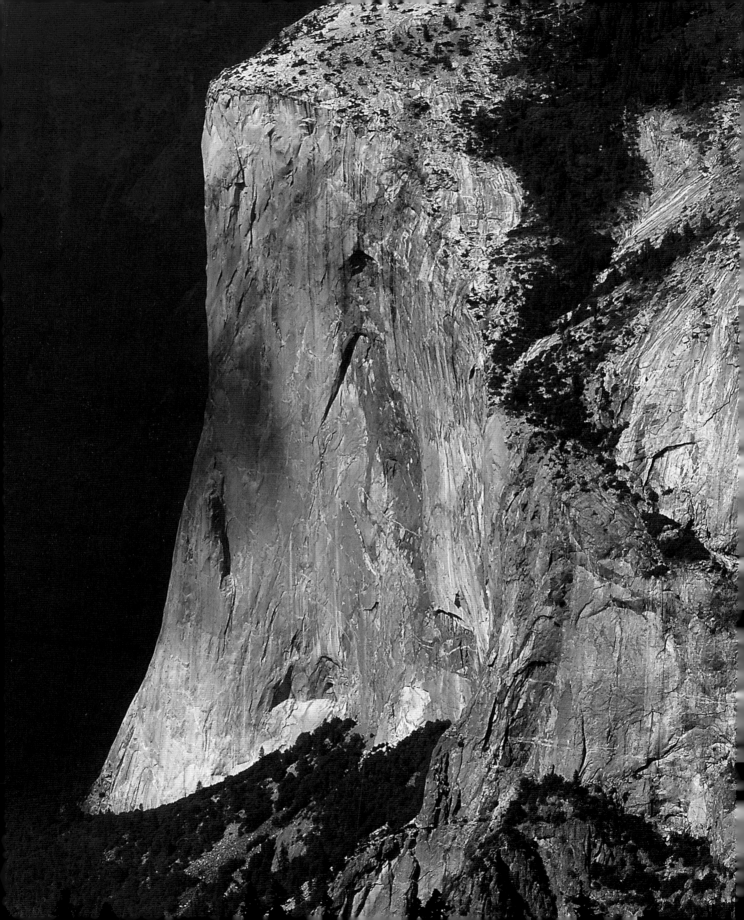

Unfortunately for Whitney's reputation, his theory was wrong.

After a few years in the Sierra, John Muir wrote a series of articles arguing that glaciers excavated Yosemite Valley. Despite the strength of Muir's evidence, few took the word of this shepherd and amateur naturalist over that of the head of the Geological Survey. When Muir heard of other Yosemite-like valleys in the range, he traveled to see them for himself. As he expected, the great chasms of the South and Middle Forks of the Kings River showed all the characteristics of glaciated valleys. Each had the U-shape cross section of glacial valleys, not the V-shape of water-carved canyons. Muir also found the other indicators of glacial origin, including glacier polish, erratics, and a succession of moraines. His studies settled the matter in Muir's favor.

In 1871 Muir found a living glacier in the Clark Range of Yosemite. Three hundred more have been identified since, including the Palisade Glacier, the largest in the Sierra, covering one square mile.

Ten years after my lengthy journey down the Muir Trail with the Bear, I returned to the Palisades in the east-central Sierra, accompanied by my wife, Terrie, her friend Marianne, and Greg Thompson. We were about to experience some of the Sierra's ancient legacy of glaciers and ice. We hiked up Big Pine Creek past elegant Temple Crag with its steep, slender buttresses arcing like samurai blades to the summit, up Sam Mack Creek, and across glacial rubble and snowfields to the Palisade Glacier. The cirque was as wild as I recalled it. A crescent of peaks embraced us. We could see four 14,000-foot summits from the tent door. Mount Sill dominated the left of the crescent with Thunderbolt Peak to its left. In the middle rose North Palisade, the highest of all. To its left, the top of Polemonium Peak, a nubbin of rock flanked on either side by the U-notch and V-notch ice gullies, barely nicked the 14,000-foot elevation. Even in high summer little sun warmed the gullies so their ice remained year-round, losing snow cover for a few weeks at the end of each summer. The Palisade Glacier looked like an unremarkable snowfield, but we could discern thin, deep crevasses, as well as bergschrunds, where the glacier had pulled away from the base of the peaks. We camped at the toe of the glacier, a center-row seat in an amphitheater of cliffs.

Greg and I crossed the glacier to Mount Sill, which the Bear and I had climbed. But this time I had my eye on Mount Sill's Swiss Arête, a moderate rock climb on an exposed ridge that would have been unthinkably steep

Left: *El Capitan in Yosemite Valley is one of the largest rock monoliths in the world. It rises over 3,000 feet and overhangs near the top.*

and technical for me with my limited skills of a decade earlier. The snow cover thinned and we walked on sun-pitted ice so rough we didn't need crampons. Once on the route we enjoyed a sunny but windy day on steep, easy rock. The view from the top felt completely different from ten years earlier given the clear conditions and my years of experience climbing—grand but not intimidating. North Palisade dominated the crest with its sheer black walls and crenellated summit.

The next day took us to the top of Thunderbolt, the northernmost 14,000-foot peak in the range, via another agreeable rock route. Once again North Palisade riveted our attention. After enjoying the view, we descended a nasty gully back to the glacier.

We saved the V-notch ice gully for last. At the time it had a reputation as one of the toughest ice climbs in the Sierra. From our camp it looked nearly vertical, but we knew foreshortening exaggerated the angle so we wouldn't encounter anything steeper than fifty degrees if a snow bridge crossed the bergschrund where the ice met the rock. At worst we would clamber into this gap (the bergschrund) between the glacier and the gully and then climb a short steep step to the gentler slope. We carried a rope and some protective devices to guard against long falls: metal wedges to slot in cracks in the rock on the side of the gully and tubular screws to place in the ice itself. We would then clip our rope to these devices.

Unfortunately no bridge gave us access to the gully, so we used the rope to rappel deep into the gap. Greg led the steep climb out, laboriously plac-ing an ice screw thirty feet up. Greg pulled out of sight and the rope ran quickly, which indicated easier going. I joined him and took over the lead. I climbed with a single bamboo-shaft ice axe, flat-footing with my crampons as much as possible. This so-called French style of cramponing takes the load off the calves but demands more precise balance than facing into the slope and kicking the crampons' front points into the ice. I alternated between balancing with the tip of the ice axe shaft on the ice and sinking the pick securely when I changed direction.

I was enjoying myself until the moment I swung the axe hard overhead and the ice shattered. I examined the axe and saw that the tip had broken. My sense of security evaporated.

I was fifty feet above Greg and had placed no protection. The closest rock where I could place a wedge was twenty-five feet away. If I fell before I got there, the bergschrund might swallow me, but I didn't want to waste time placing an ice screw. I calmed myself, front-pointed methodically to the

Right: *The Palisades dominate the view above lonely Barrett Lake in Kings Canyon National Park.*

Following page: *The sky comes alive above Mounts Winchell and Agassiz as seen from the Palisade Glacier east of the crest.*

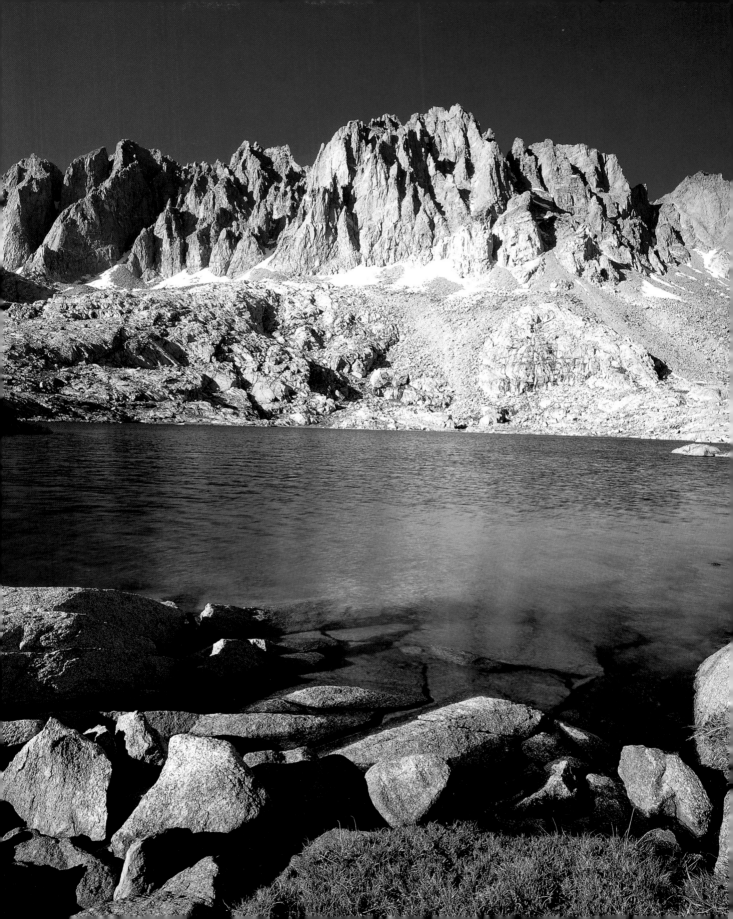

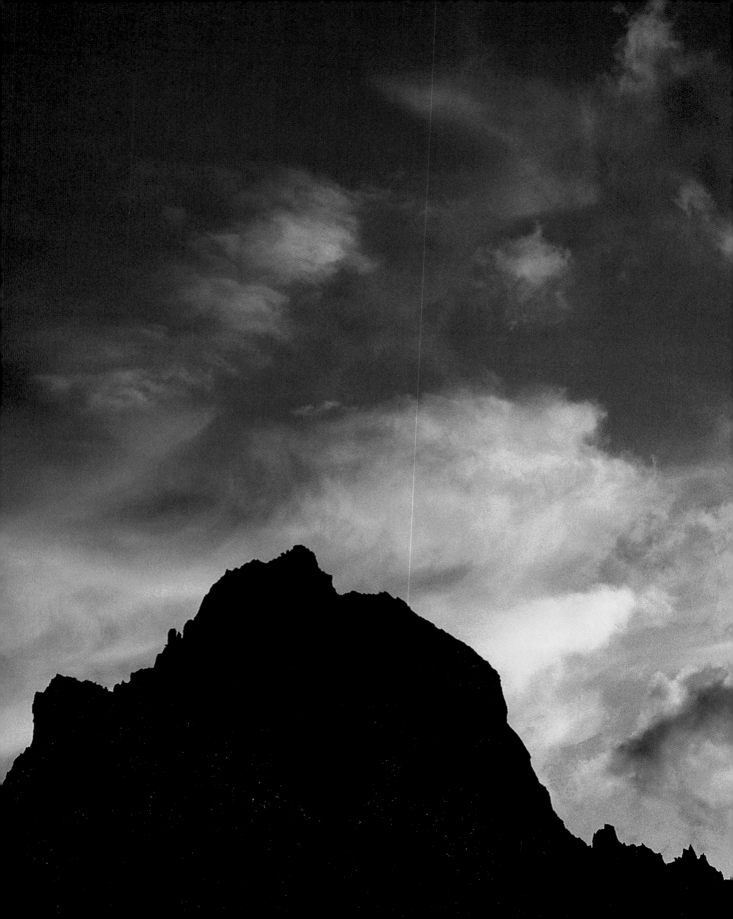

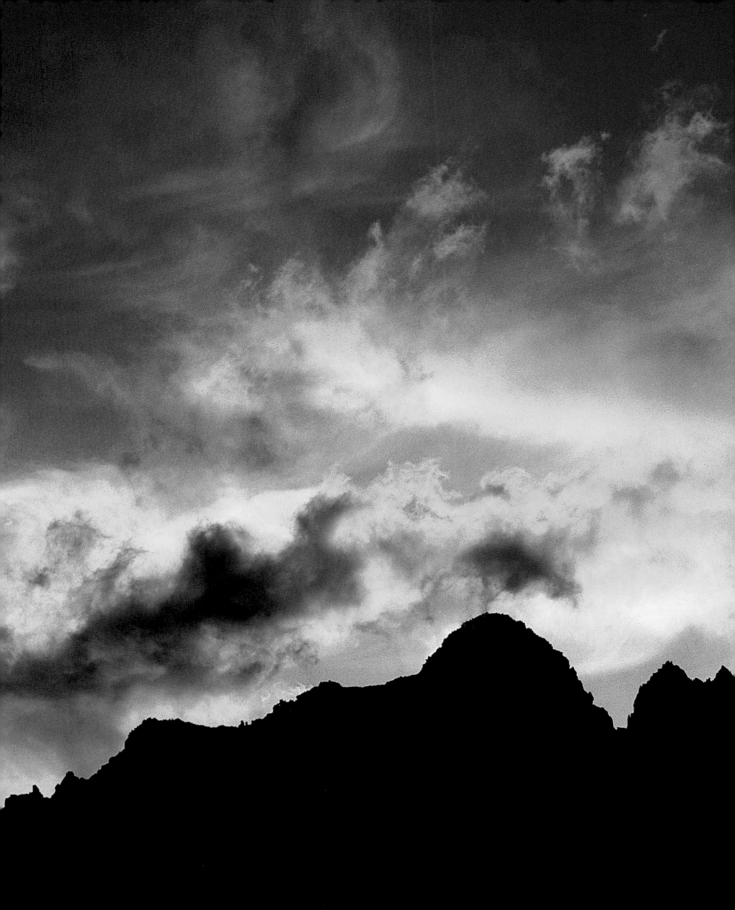

rock, and placed two wedges. Greg climbed to the anchor I created and after one look at my damaged axe, he suggested retreat. But I thought he should lead on with his good axe.

So we moved quickly upward. Greg led to the top of the gully in one push. We traversed over the summit of Polemonium Peak, a 14,000 bump between Mount Sill and North Palisade. A few of its eponymous flowers shuddered in the breeze.

After a snack, we rappelled into the U-notch, a gentler gully running up to the summit ridge of North Palisade. I assumed we would then rappel down the gully, secure on a rope, but Greg just started walking down. The surface alternated between hard snow and bare ice. I wasn't mentally prepared to walk down one of the harder gullies in the Sierra, but Greg assured me this was standard procedure in his home mountains, the Cascades of Washington state.

"Just keep your weight over your feet," he advised as he disappeared over the brink. I tested my crampon points. They held. I looked at my broken axe; there would be no self-arrest if I popped off, and a bergschrund gaped hungrily at the bottom. Trusting to physics, I started down the steepening slope.

The points bit with a reassuring crunch, and I became comfortable. Astonished climbers laden with full packs, placing ice screws and front-pointing with their crampons, watched us stroll down their climb. We crossed the bergschrund less than half an hour later. Our route to camp crossed dozens of small crevasses just inches across, proof this was living ice, but the lines of moraines below indicated a glacier in retreat. Someday the glacier could fill the basin again. The walls would echo with falling ice and crackling crevasses for thousands of years until the glacier receded again to reveal a newly carved landscape.

Right: *Ice encrusts an oak in Yosemite Valley.*

Following page: *The morning sun blazes over the summit of Middle Palisade, seen from above Palisade Lakes en route to Cirque Pass.*

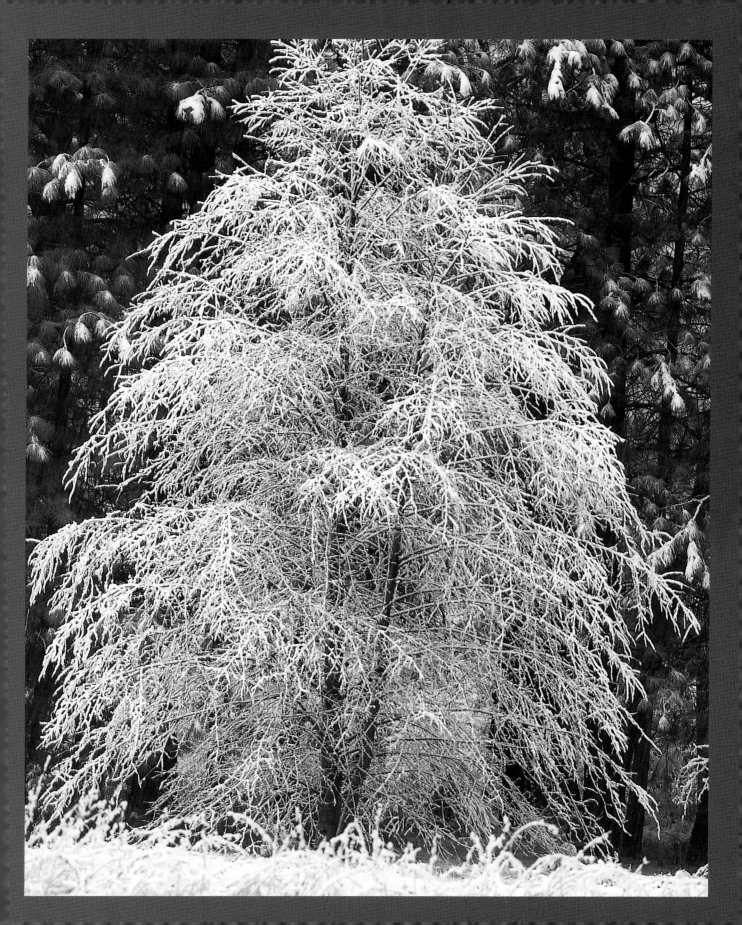

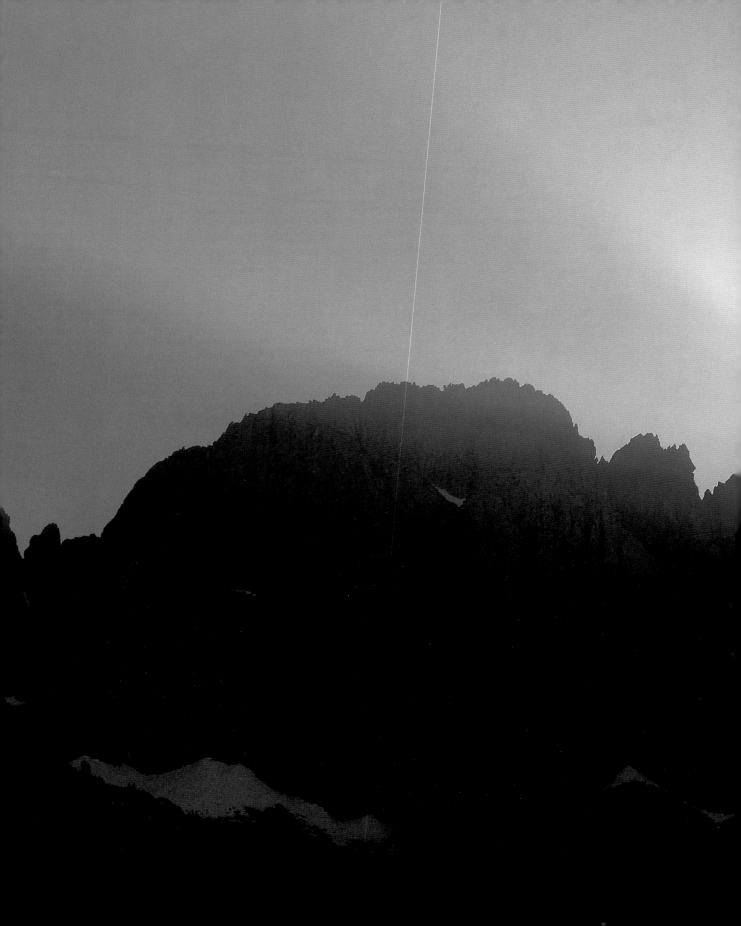

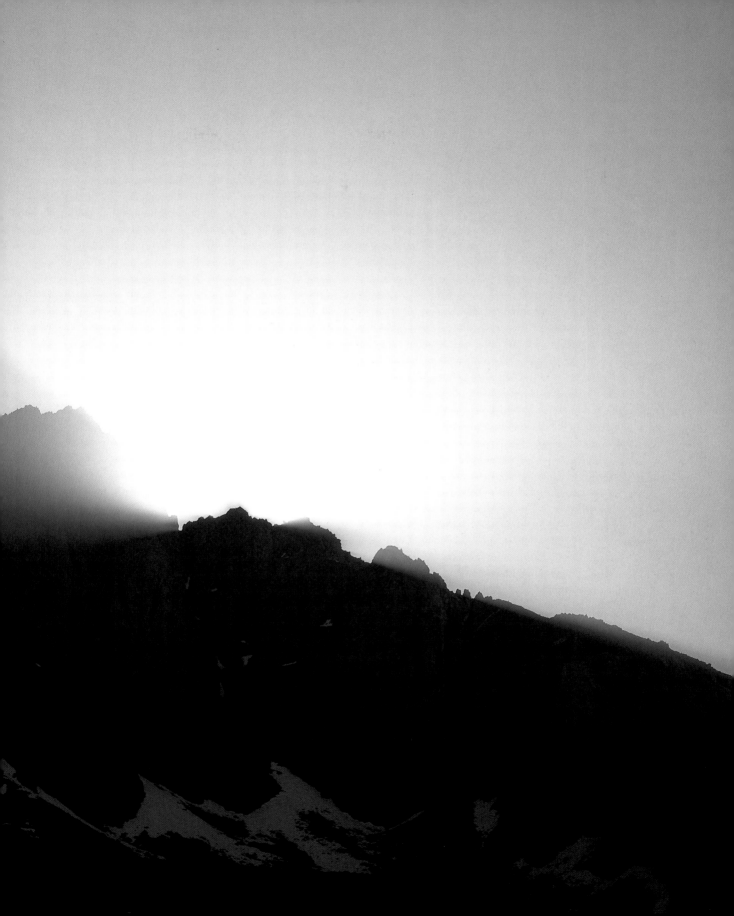

Muir

"The power of the wild

coursed through him."

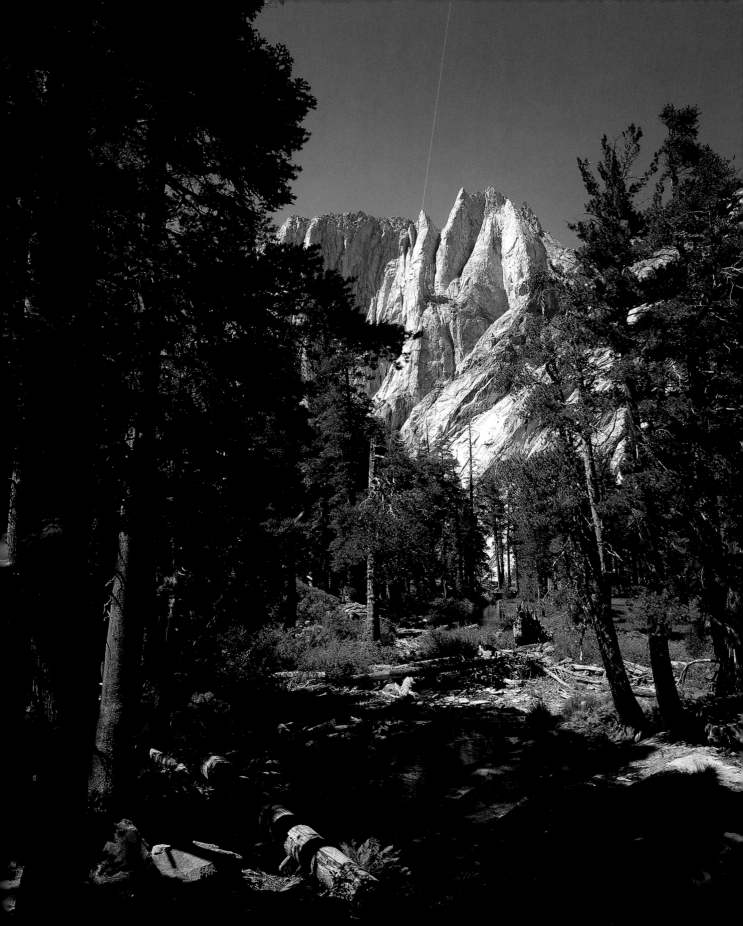

Muir

When I first encountered the writings of John Muir, I felt an instant kinship. He wrote a florid Victorian prose, awash in adjectives and almost flying apart with enthusiasm. He married the mystic vision of a Saint Francis with a hard-headed Scot's practicality, gushing one moment about God's light and deducing the path of ancient glaciers from striations on granite the next. I was struggling to reconcile a need for logical rigor with a powerful response to beauty. The disparate elements of Muir's character seemed to mirror my own, or so it seemed to a sixteen-year-old.

I decided to approach the wilderness his way. There were harsh lessons ahead for a coddled suburbanite planning to emulate a nineteenth-century

ascetic. Muir was indifferent to discomfort. He hiked for days carrying nothing but a few crusts of bread in his coat pocket and slept where night found him. In forests he fashioned a bed from evergreen boughs, but in the high country he huddled amid boulders, shivering. If he found fuel for a fire, he fell asleep next to the flames, waking when the fire died. Muir moved quickly. He could cover twenty-five miles a day without a trail. At the end of a trip he returned skinny but exalted.

Inspired by Muir's accounts of his travels in the Sierra, I decided to hike in California's Santa Cruz Mountains carrying nothing but a Sierra Club tin cup, a wool blanket, and a bag of dried oatmeal. I walked one autumn weekend to a waterfall in Big Basin State Park. It was a cold, damp camp. I chewed my oatmeal and chased it with water. When night came, I wrapped myself tightly in the blanket, but the moist coastal damp penetrated the wool so I spent the night shaking against the cold. I decided to add a few creature comforts to my kit next time.

John Muir spent his first eleven years in Scotland and never lost his native brogue. The family emigrated to Wisconsin, where he worked the farm with his father. After a short stint at the University of Wisconsin, he temporarily lost his sight in an accident. When his vision returned, he vowed to devote the rest of his life to the study and appreciation of the natural world and set out wandering in 1863. He spent some time in Canada, perhaps to evade the Civil War draft. He found himself in Louisville, Kentucky, and decided to walk to the Gulf of Mexico. Upon arrival, he booked passage to Panama, crossed the Isthmus, and boarded another vessel to San Francisco. A final 250-mile hike though the flower fields of what was to become Silicon Valley and through the San Joaquin Valley brought him to Yosemite and the High Sierra in the summer of 1868. The beauty and grandeur he found there dazzled him and changed the direction of his life.

He recounted his experiences in *My First Summer in the Sierra*. While much of the text centers on Muir's adventures and his response to what he called the Range of Light, he also noted how settlers were despoiling the wilderness. He especially decried the grazing of sheep in alpine meadows, referring to the animals as "hoofed locusts." His outrage became the seed of the preservationist movement in the United States.

Muir's voice was the first to clearly articulate the position that we should protect wild lands for their inherent value, not so we could extract their resources. He saw the wilderness as a place for spiritual refreshment and as a window to the mind of God.

Right: *Deer graze in Crabtree Meadows, Sequoia National Park, in the shadow of Mount Whitney.*

He embarked on a campaign to save the Sierra from commerce. First, he preached his gospel in a series of books and articles. Next, he led politicians, businessmen, and other influential people on trips into the mountains. Impressed by Muir's passion and the landscapes he championed, they formed the group that would become the Sierra Club in 1892. Under Muir's leadership, the Sierra Club spearheaded the fight to maintain park status for Yosemite against development interests that sought to open the park to business. Muir camped with President Theodore Roosevelt in Yosemite for three days, and his influence on the president speeded the transfer of Yosemite to federal control. Over the years the Sierra Club persuaded Congress to add to Sequoia National Park, culminating in the creation of Kings Canyon National Park in 1940 after Ansel Adams and David Brower lobbied the government with stunning photography and impassioned prose.

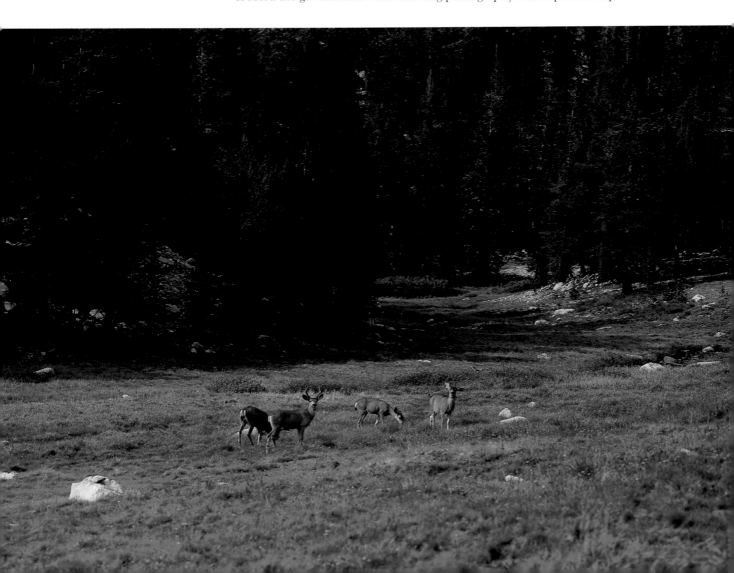

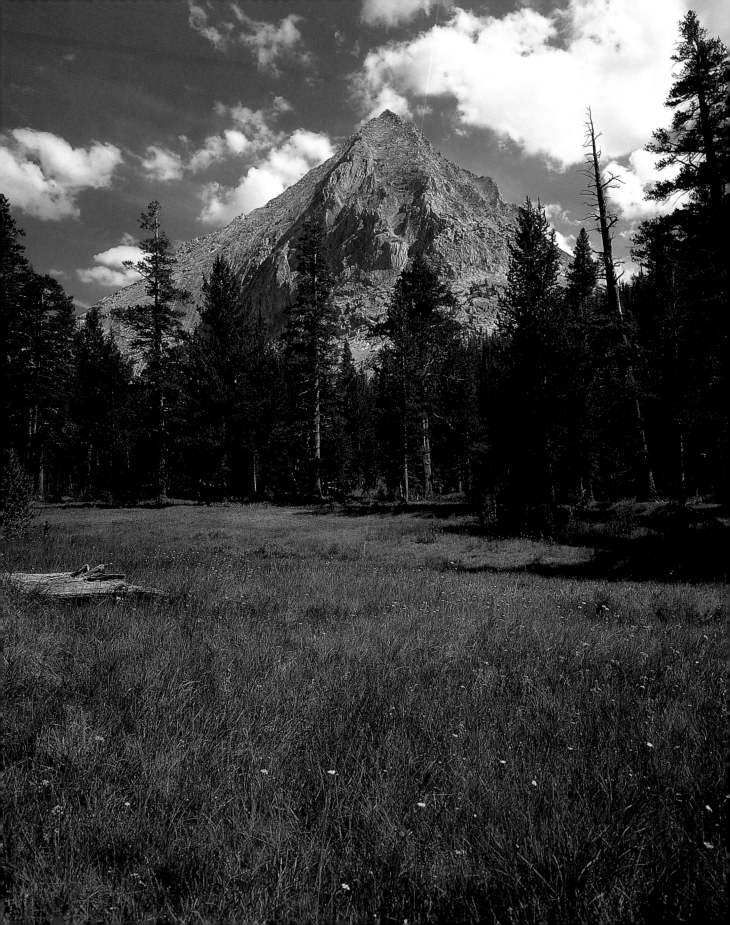

As I sat on the summit of Mount Whitney for the first time, in 1968, a tremendous explosion shook the peak. Moments later two military jets roared past at summit elevation. I could see a string of people on the trail to the top stopping to look at these sources of the explosive interruption. To the west the peaks of the Great Western Divide appeared bleached in haze thick as smoke, a combination of dust, smog, and moisture, as if the Central Valley was afire. I wondered what Muir would think of the state of his Sierra.

Some problems were beyond imagining for a nineteenth-century man. The burgeoning population and easy access to the high country led to over-use, proving booted locusts no less destructive than hoofed. For years large parties cooked over fires and burned every scrap of downed wood near camp, dug latrines close to water, and created footpaths that flattened natural gardens and eroded hillsides. Their horses' hooves chewed up the trails, and the horses grazed on fragile meadows. Federal wilderness managers finally began limiting party size and pack animal grazing. Regulations now ban fires in the high country because plant life depends on rotting wood.

I revisited the Sequoia and southern Kings Canyon components of the Muir Trail in 2000 and actually found fewer hikers than in 1968. The trail seemed to be in better condition, and I saw no horses. While regulations doubtless contributed to the improvement, a decline in the popularity of backpacking surely helped as well. Someday the pendulum will swing back, and the managers will need to be ready to control the crowds.

For a preview of a possible future, check out the trail from Whitney Portal to the 14,494-foot summit of the highest mountain in the contiguous United States. Most hikers must reserve space on the trail, and even day-hikers must carry a permit. While I saw the usual backpackers and climbers, the scene also included runners who were racing from Death Valley to the summit, bikers on foot but still wearing their leathers and motorcycle boots, European visitors with minuscule packs that couldn't contain even rudimentary survival gear, a walker radiating the look and aroma of a person with a broken mind, and a few guys jogging with heart monitors and hydration systems. I wouldn't presume to restrict any folks from visiting the mountain, because beauty can surprise and affect anyone, but many of them seemed preoccupied with their lowland agendas, as if hiking with their eyes closed.

Left: *Vidette Meadow is the last grassy forest southbound hikers see on the John Muir Trail before they climb over 13,057-foot Forester Pass.*

Following page: *The Great Western Divide, seen here from the Bighorn Plateau, parallels the crest in Sequoia National Park.*

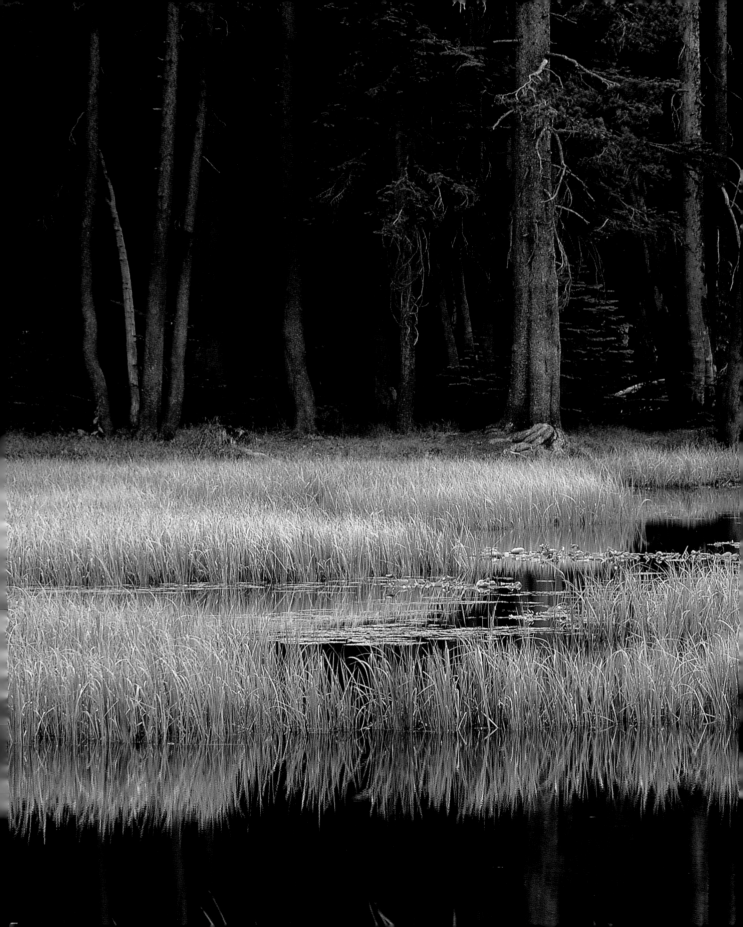

The mountain lakes seem less clear than in earlier years. Algae clouds the water where once you could see to the bottom of deep lakes. Pollution from hikers may account for some of the problem, though air pollution from the Central Valley and beyond is the likely primary culprit. Car exhaust from urban areas and agricultural byproducts such as phosphates and other fertilizer chemicals are carried by the prevailing winds to the Sierra. Consequently, nitrogen and phosphorus levels have been escalating, providing nutrients for the growth of algae.

In 1968 I drank from lakes and streams without a care. Today, if I did that I might well contract the disease giardiasis caused by microscopic *Giardia* organisms that can enter the water from the feces of affected animals or humans. The feeling of wilderness purity has been diminished, perhaps forever.

Left: *Subalpine lakes like this one in Yosemite fill with sediment and become meadows and later forests.*

Below: *Muir counted alpine heather as his favorite flower. It huddles among the rocks above timberline.*

Following page: *In late summer, ruddy rock from ancient volcanoes glows at sunset above the Dana Fork of the Tuolumne River.*

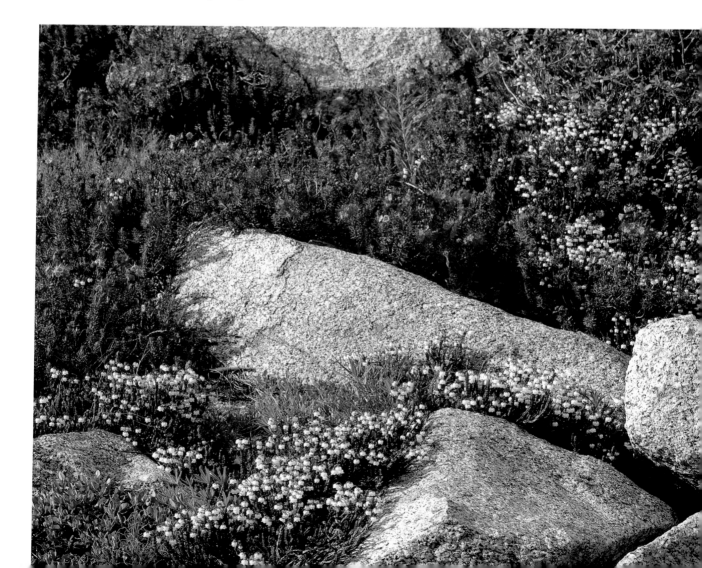

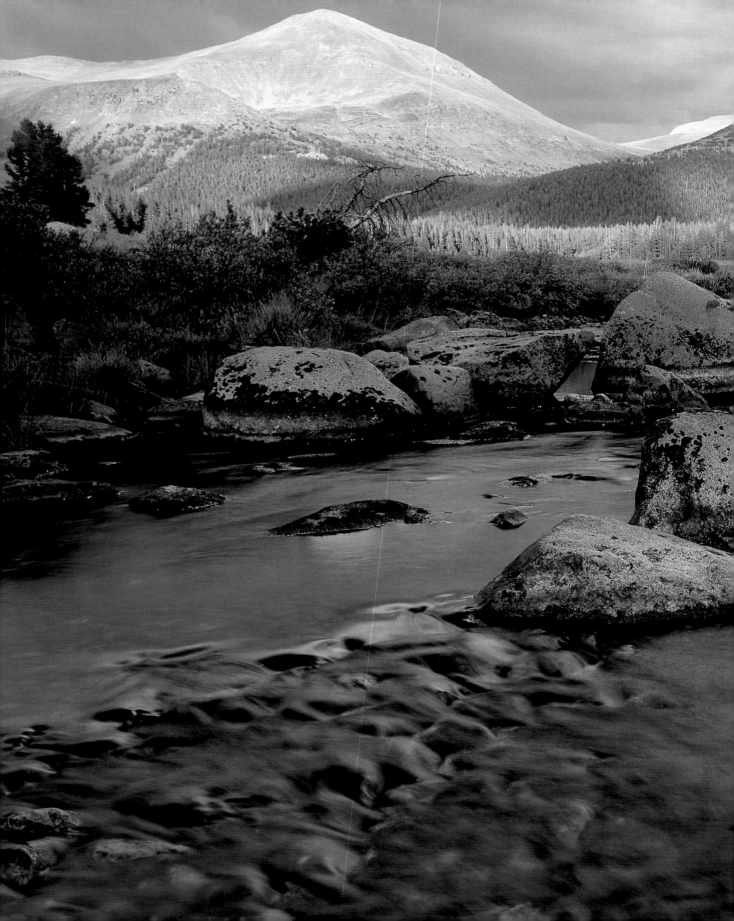

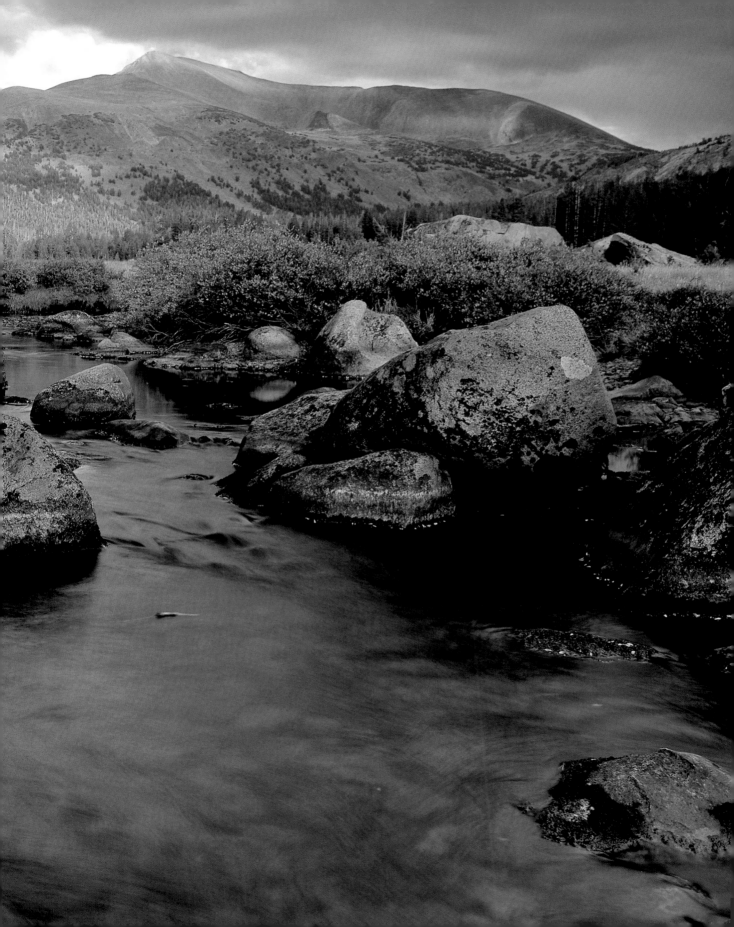

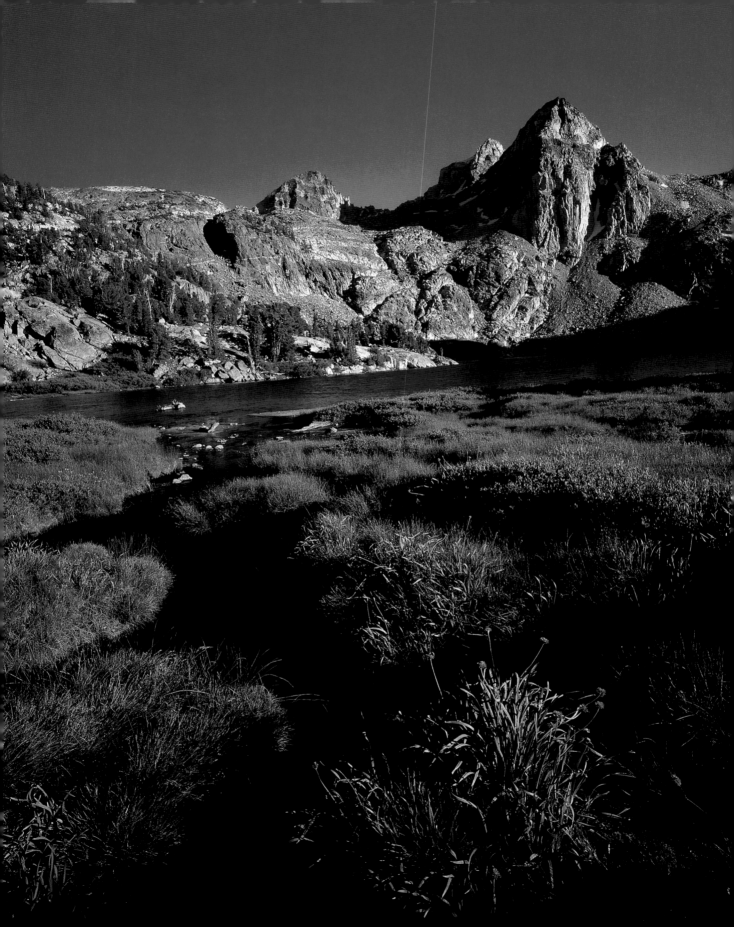

Still, I feel optimistic. The people I meet in the high country manifestly love it and will struggle to save it. Even the family sitting in an RV in Yosemite Valley watching *Wheel of Fortune* seems to object to the erosion of wilderness protections. Over the years, Sequoia National Park has been expanded several times, surrounding territory has gained protection as wilderness, additional stands of sequoia trees received protection with the creation in 1999 of Sequoia National Monument, and any number of goofball development schemes and proposals for cross-Sierra roads have been beaten down.

As important as Muir was to the preservation of our wild national treasures, it was his personality as conveyed through his overheated writings that fired my imagination. The power of the wild coursed through him. He could feel the interconnectedness of all things both as a scientist and as a visionary. Only a mystic could write, "When we contemplate the whole globe as one great dewdrop, striped and dotted with continents and islands, flying through space with all other stars all singing and shining together as one, the whole universe appears as an infinite storm of beauty. The clearest way into the Universe is through a forest wilderness." And only a scientist would note the distribution of sequoias, the meanings of geological features, and the behaviors of animals. I remember staring at photographs of Muir when I was young. I saw something appealing in the wild hair and penetrating gaze. It seemed that light flowed out of his eyes, as if everyone else in the photograph was inanimate. I knew I couldn't be Muir, but I wanted to see what he saw and feel what he felt.

His love of the wild led him into strange adventures. During a violent winter windstorm along the Yuba River, he sought a more intimate appreciation of its power by climbing a one-hundred-foot Douglas fir. To his delight, it "flapped and swished in the passionate torrent, bending and swirling backwards and forwards."

While Muir hiked near the rim of Yosemite Valley one winter afternoon, an avalanche swept him away. He sprawled on his back and flailed to stay afloat. He arrived at the valley floor unharmed and exhilarated. His solo climbing sometimes put him in a tight spot. On the first ascent of Mount Ritter, south of Yosemite, he found himself psychologically paralyzed, unable to move up or down and believing he was about to fall to his death. But a calm clarity came over him, and once fear subsided, he continued easily to the top.

Left: *Dikes crisscross the north face of the Painted Lady in Kings Canyon National Park.*

Following page: *A tunnel opens below the lip of Vernal Falls in Yosemite to provide a unique perspective.*

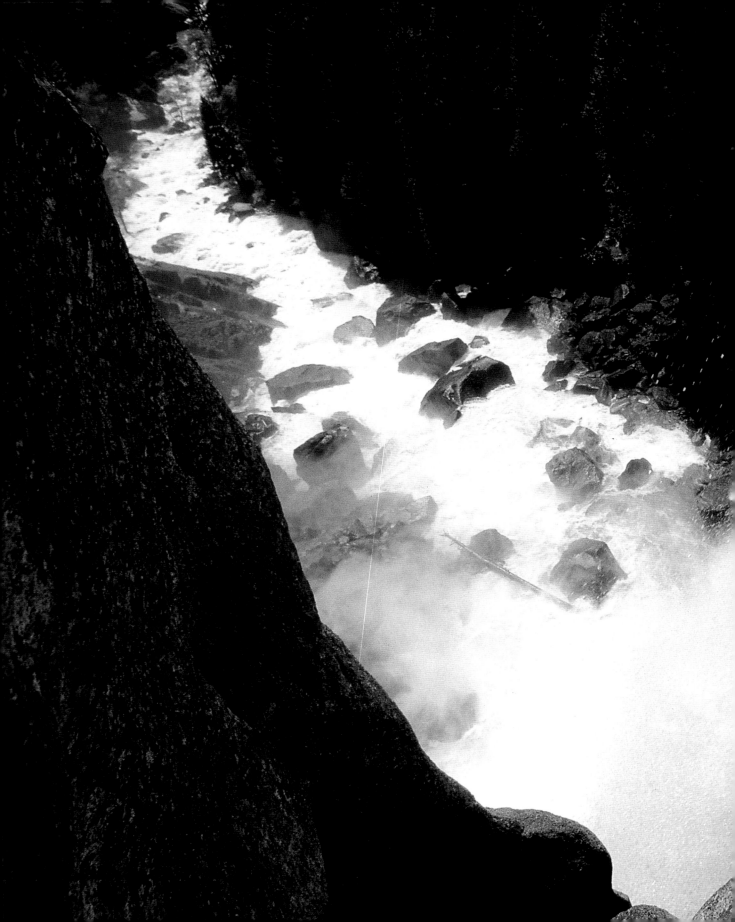

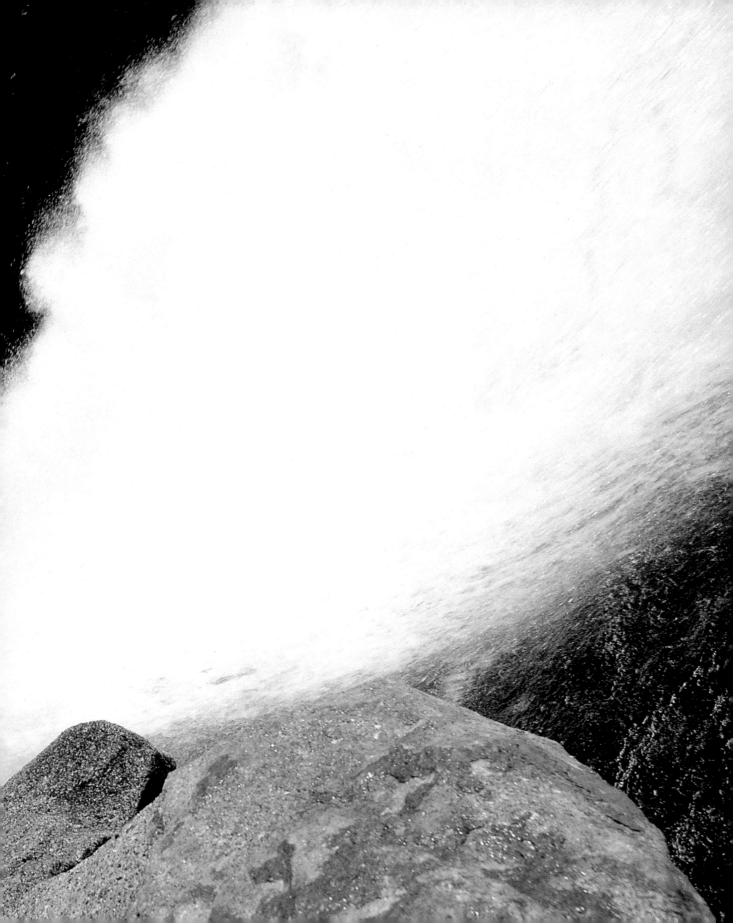

One adventure caught my fancy above all others. One winter evening Muir climbed to the base of Upper Yosemite Falls, the grandest waterfall in North America. He made his way into a cave at the base of the falls so he could see the full moon through the spray. He was able to enter the cave because the wind had blown much of the water to the side—but when the wind subsided, the full force of water falling over 1,400 feet pummeled him. He crouched and took the beating until renewed gusts allowed him to escape.

I loved the falls and would spend hours watching it change from a hail of comets to a cloud of smoke, roaring all the while. I persuaded some friends to join me on a trek to the cave. It was late June, so the full flood of spring had passed. We left the trail and followed granite benches to the base of the falls. The rock grew slippery as we neared the cave. A slip would send us down hundreds of feet of cascades and over the lower falls, a 300-foot drop. The roar became a howl. The wind generated by the falls chilled us. By the time we entered the cave, everyone was shivering.

I felt like I was in the throat of a monster. We couldn't hear ourselves shout and found it difficult to breathe in the mist, but I reveled in the raw power. Too soon the chill drove us out, but I felt lucky to have made contact with something so wild. I knew that Muir, too, recognized his good fortune. His writings read like prayers of thanksgiving for the joy of running wild among the polished stone of Yosemite, for meeting storms and avalanches and rushing water on their terms, for hearing the heartbeat of the world unmuffled by the habits of civilization.

Right: *Upper Yosemite Falls resembles smoke as midmorning sun finally arrives.*

Following page: *A rock climber leads Reeds Direct, a classic crack above the entrance to Yosemite Valley.*

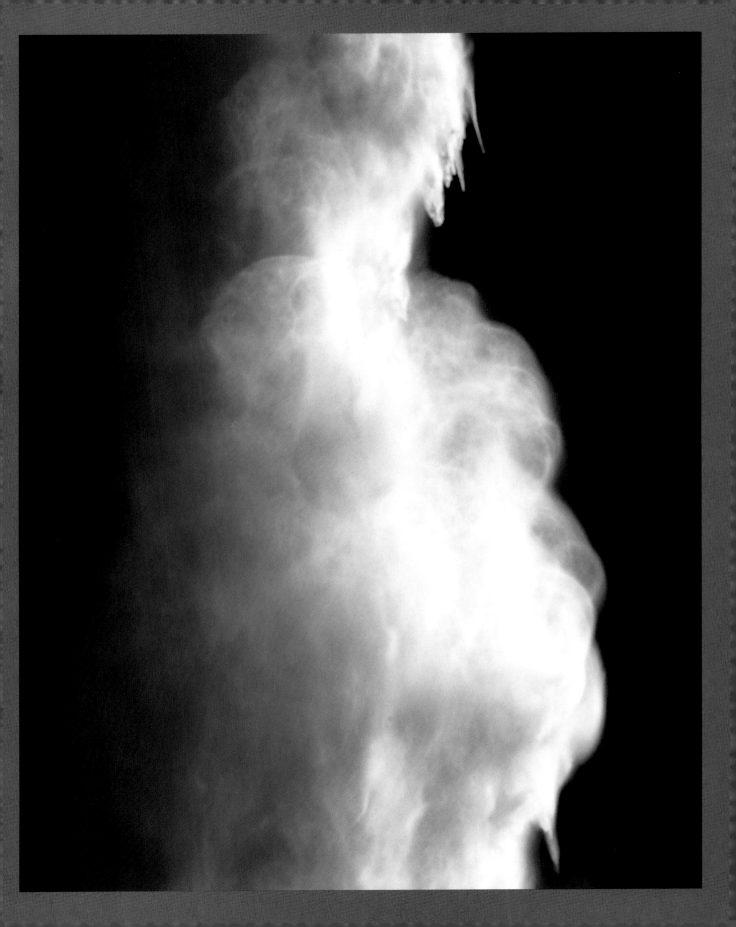

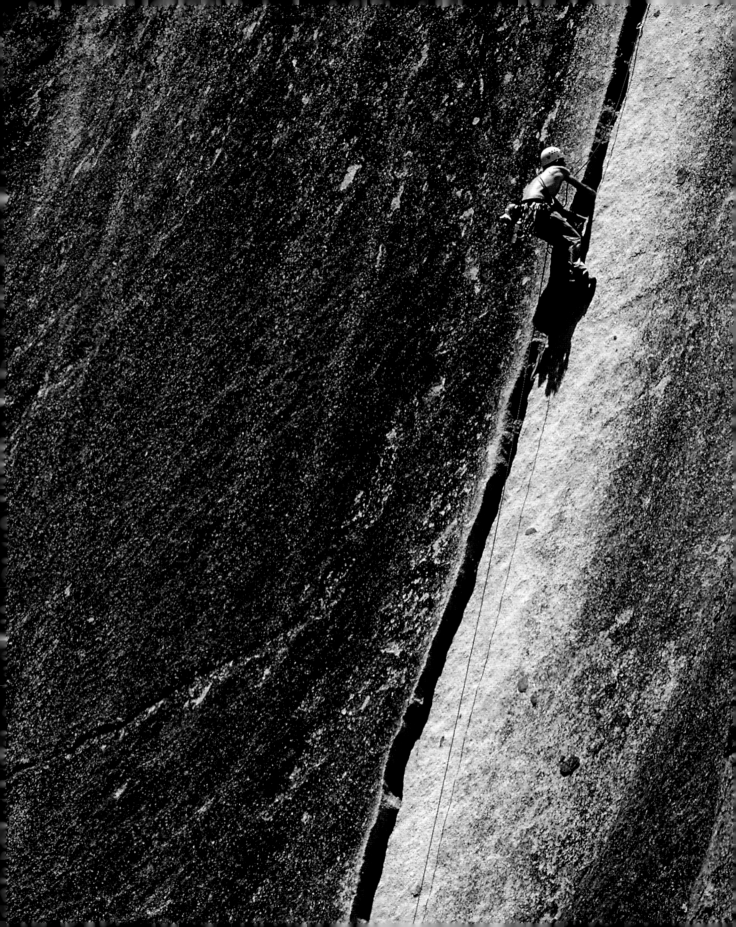

Climbers

"Seldom-seen ribs

of clean rock await..."

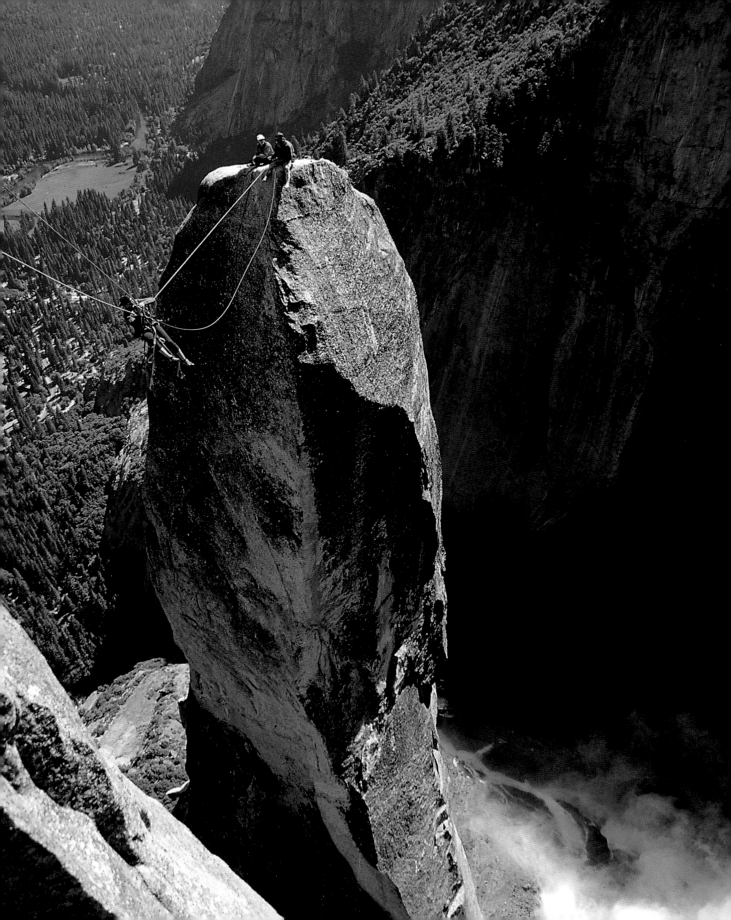

Climbers

When we started the hike to Mount Tyndall, I believed the climbing gods were on our side. A few minutes from the car we came upon an old man springing down the trail. He looked hunched and weathered but moved fluidly. A torn and faded green pack rode high and he sported what appeared to be homemade dark glasses. Tom asked him about conditions up high so he paused and gave us an enthusiastic appraisal with a smile. He introduced himself as John Mendenhall.

I was stunned. I knew the name from his books on climbing written with his wife, Ruth, and knew he had made some early climbs in the Sierra, including the first ascent of Mount Morrison, in 1928. I figured him

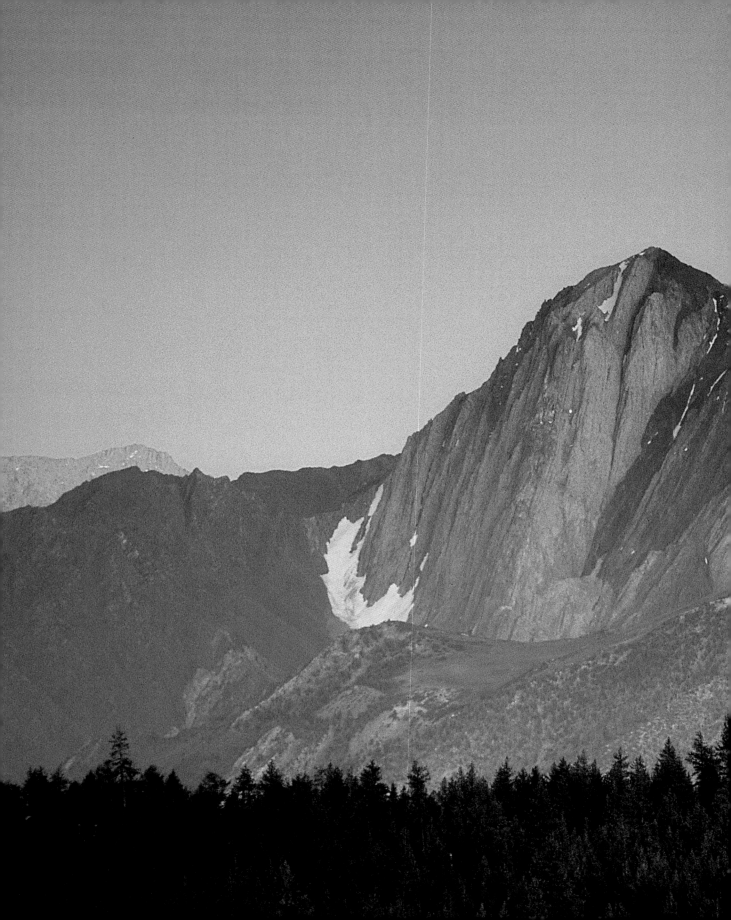

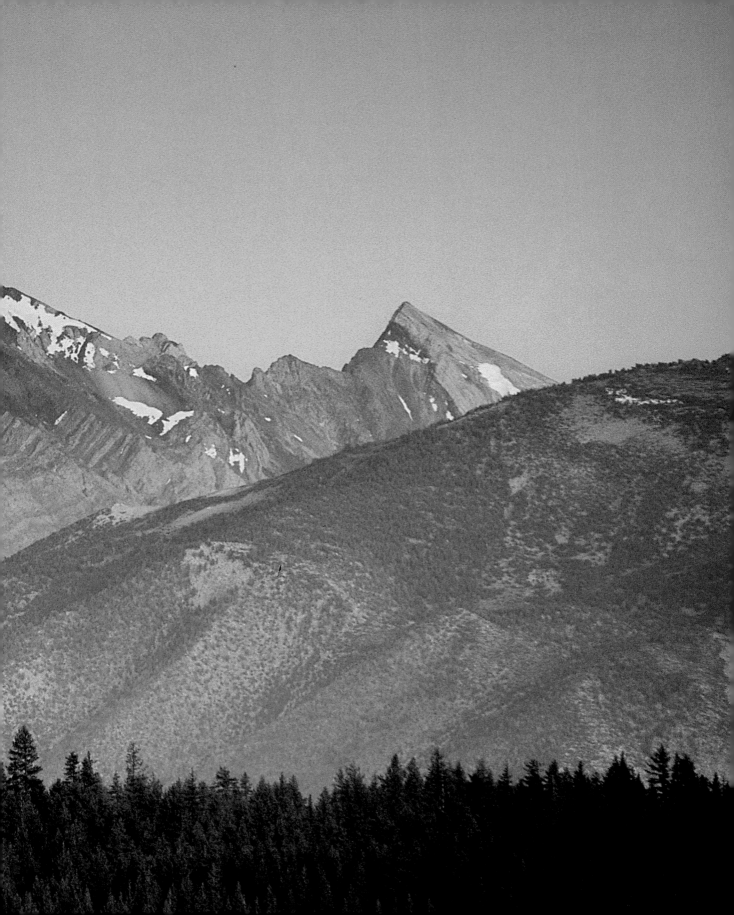

for seventy at least but he moved like a human rubber band. He had just descended one of the most feared passes in the Sierra, Shepard Pass. We were on our way to the pass, up a trail that rises from the baking heat of Owens Valley to over twelve thousand feet and features a soul-killing loss of altitude partway up. I was impressed. I was even more impressed as I struggled into camp that afternoon, flattened by the effort. The next day Tom and I reached the pass, dropped our packs, and scrambled toward the top of 14,018-foot Mount Tyndall via the North Rib.

Tom Applegate and I were unburdened by ice axes, crampons, rope, or much skill when we scrambled down from the summit. Tom managed the North Face store in Berkeley, California, where I worked, and we were on a lightning trip to climb two 14,000-footers over a long weekend.

We could see the next day's objective, the taller Mount Williamson, to the southeast. I moved cautiously down an easy rock rib while Tom chose a three-hundred-foot snow slope. The snow on this east slope had hardened in the afternoon shade, and I felt uncomfortable on it. Tom, Colorado-bred and an expert skier, jammed the edges of his boots an inch into the snow, the soles perpendicular to the fall line.

"It's just like skiing. Set an edge and weight it," he explained. I looked apprehensively at the jumble of talus waiting at the bottom of the slope.

Below: *Dead trees are silhouetted against the dawn colors on a dry ridge east of the Minarets near Mammoth Mountain.*

Right: *Don Mason poses for a rappelling photo from Glacier Point while Half Dome looms in the background.*

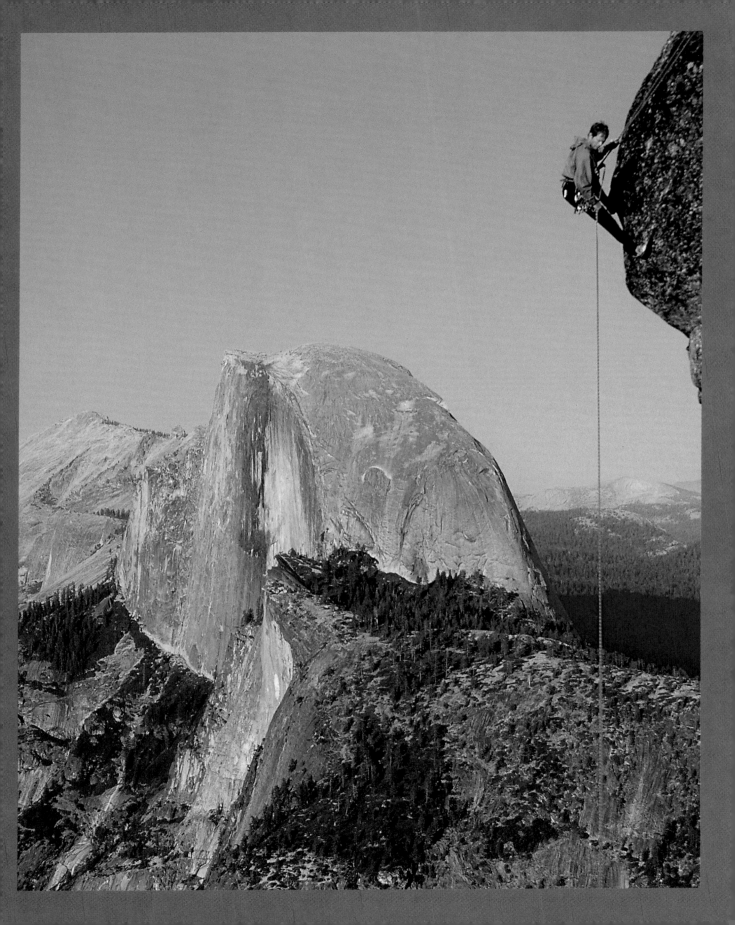

Left: *Dogwood blooms in April in Yosemite Valley.*

Below: *Oaks, cedars, and pines grow among the remnants of ancient moraines in Yosemite Valley.*

Almost immediately the tiny platform of snow beneath Tom's boots collapsed, sending him hurtling soundlessly toward the rocks. A few dozen yards before impact, he slid across a tongue of granite flush with the snow and came to a stop. I downclimbed as fast as I could and called out, "Are you all right?"

"I want to go home to my wife now."

I didn't argue. Big Willie could wait.

Night caught us halfway down the Shepard Pass trail, but a full moon supplied enough light for hiking. I enjoyed cruising down the sandy trail,

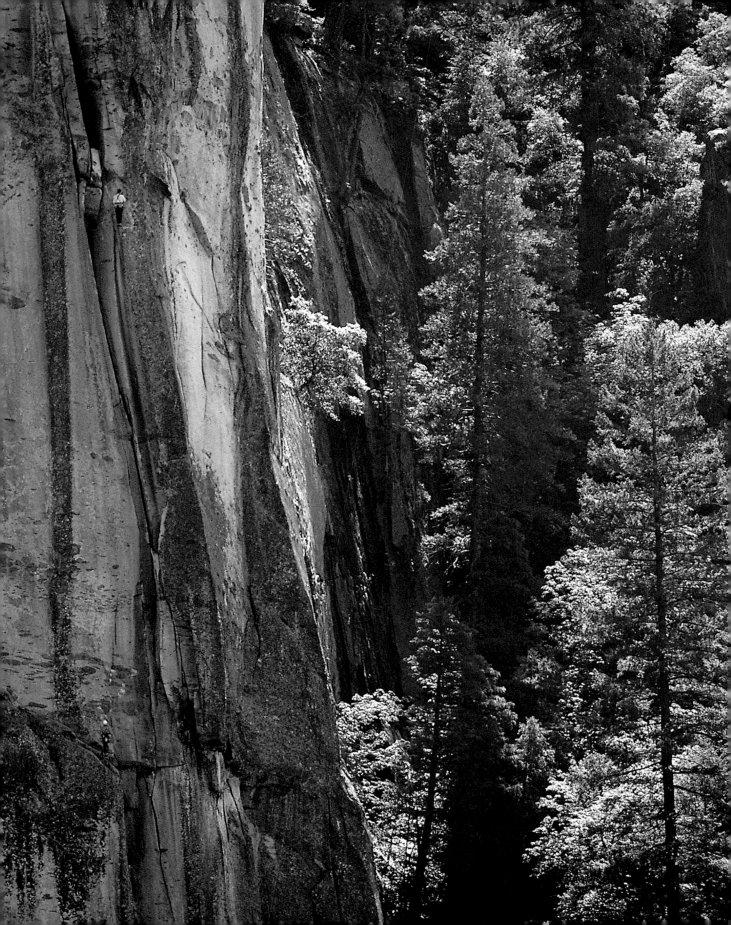

inhaling the scent of manzanita and glancing at the great wall to the south glowing white as Annapurna, all scale obliterated by moonlight. We camped a couple miles from Tom's car, and arrived there shortly after dawn, celebrating our safe return with the Harp beers we left cooling in the trunk. Ours was not the most distinguished expedition in Sierra history, but we felt a sense of accomplishment and grace as we sped home.

Left: *The Rostrom is a stiff crack climb in the canyon below Yosemite Valley.*

Right: *An early October snowstorm dusts the peaks above 60 Lakes Basin.*

Following page: *Graceful Isosceles Peak in Dusy Basin is a minor summit compared to the neighboring Palisades.*

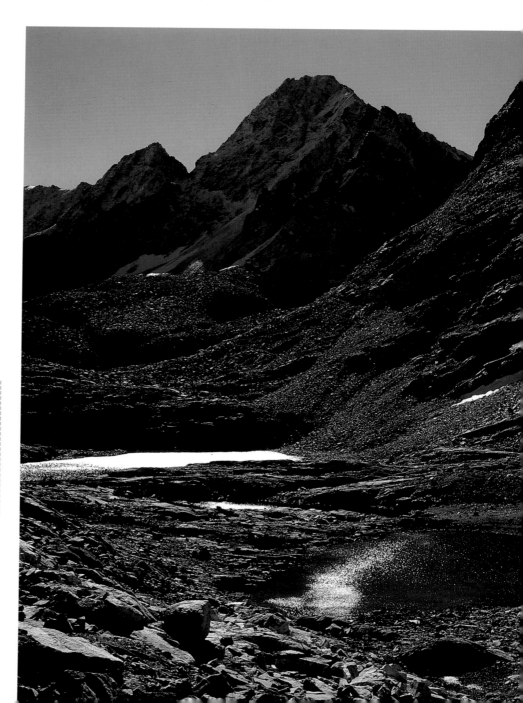

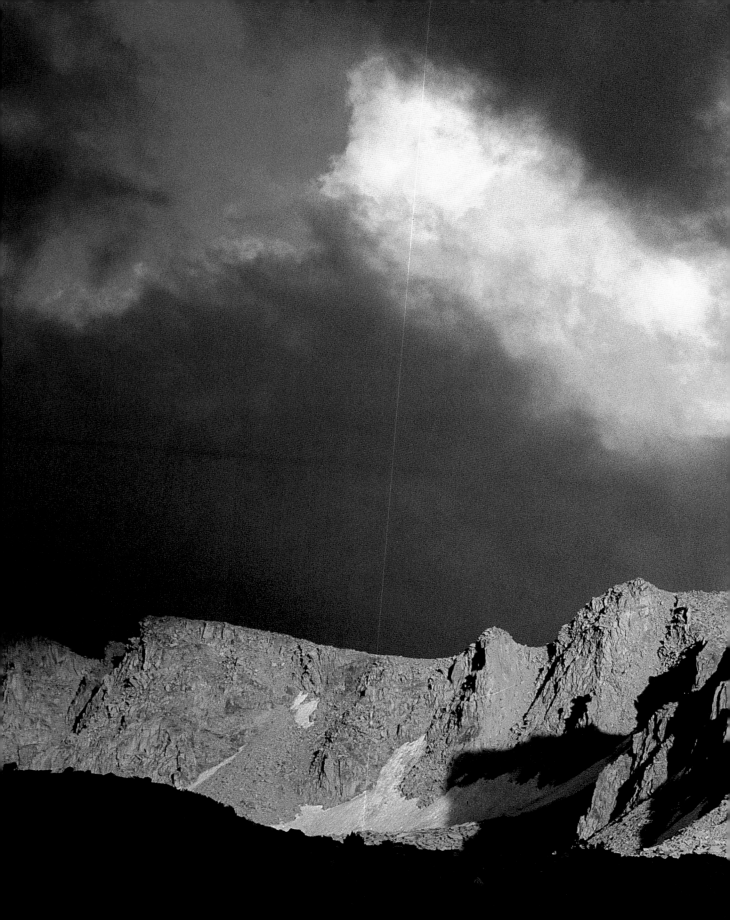

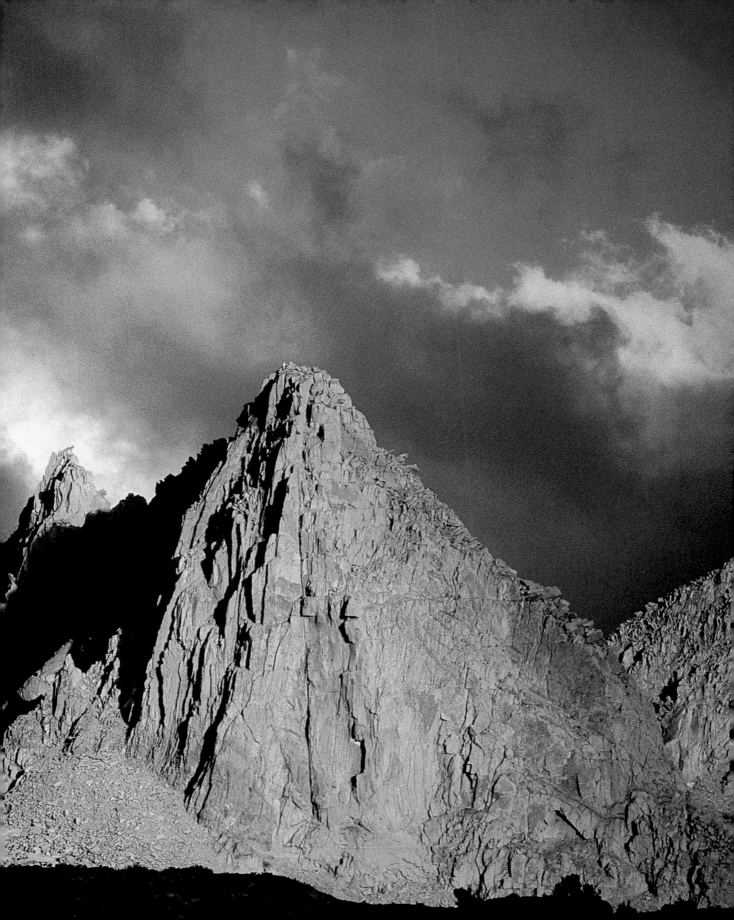

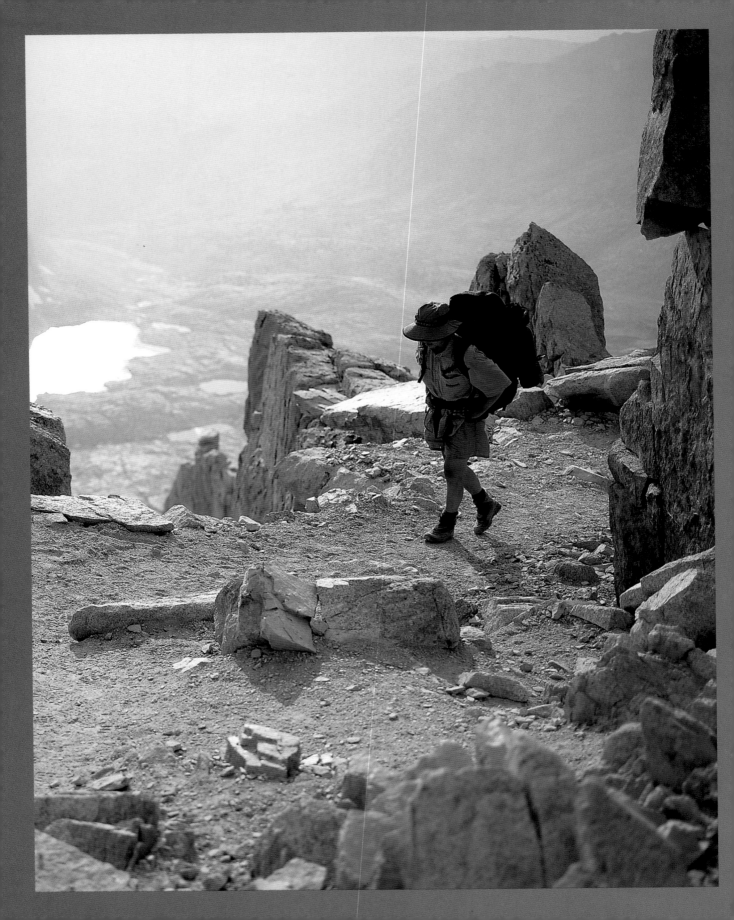

The first Sierra climbers were explorers and scientists. They sought expansive views as they mapped the range, so they chose tall, easy mountains. In 1863 members of the California Geological Survey (Josiah Whitney, William Brewer, and Charles Hoffman) climbed Mount Dana near Tioga Pass. Whitney thought it must be the highest peak in the range, but at 13,053 feet it isn't even the tallest in Yosemite, while hundreds of summits are higher in Kings Canyon and Sequoia National Parks.

The following year, twenty-two-year-old Clarence King volunteered for the survey at no pay. King and his friends Richard Cotter and James Gardner joined Brewer and Hoffman on a survey of the southern part of the range.

They got their first view of the high country from the summit of Mount Silliman near Giant Forest in the present Sequoia National Park. The group mistook the peaks of the Great Western Divide for the main crest of the Sierra. The Divide almost parallels the Sierra crest five to ten miles from the crest. The Kern River flows south between the crests in a deep canyon. They could see that a particular mountain at the northern terminus of the Divide was the tallest in view so they headed toward this steep and lovely pyramidal peak, later named for Brewer. Brewer and Hoffman made it to the top with some difficulty, then realized the main crest of the range paralleled the Divide but was six miles to the east. They named the closest giants Tyndall and Williamson, but the tallest of all stood farther south. Brewer named it after their leader, Josiah Whitney. King immediately begged Brewer for a chance to climb Mount Whitney. Brewer considered the idea mad, given the distance and rugged terrain, but he eventually relented and allowed King and Cotter to try.

King recounted his exploits, real and imagined, in *Mountaineering in the Sierra Nevada.* The pair shouldered forty-pound packs with provisions for five days, scientific equipment, and rope, and sallied forth to find a route across the Divide. From King's description they chose poorly. Cross-country hikers traverse the Divide via one of four moderate passes. King and Cotter found themselves on cliffy terrain that forced them to lasso rock horns and climb hand over hand on their rope. Once over the top, they used the rope to descend a series of cliffs. After negotiating the Divide, they crossed the broad Upper Kern plateau. They could see Mount Whitney but concluded that their stores would run out before they could reach it. Nearby Mount Tyndall became the new goal.

Left: *A hiker nears Trail Crest high on the shoulder of Mount Whitney.*

Following page: *By late summer the spring flood abates to a trickle at Vernal Falls*

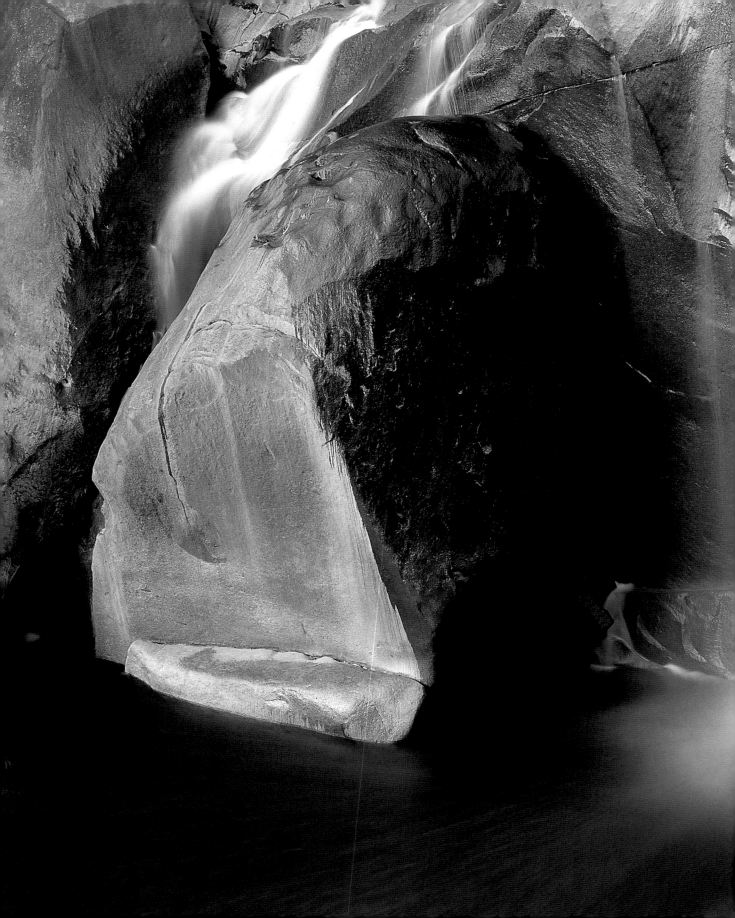

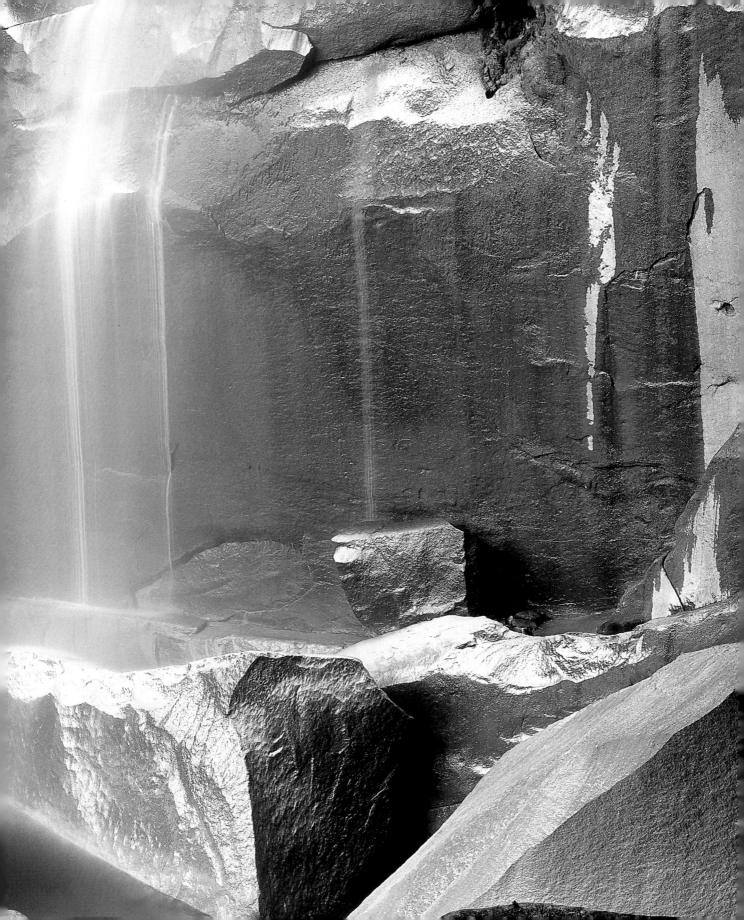

Climbers rate the North Rib of Tyndall as a Class 3 climb, a scramble not requiring a rope. According to King, he and Cotter ascended near-vertical ice, cutting shallow steps to make progress, finally shimmying up a detached icicle to the summit. This terrain is not discoverable today. While King's toughness, scientific ability, and enthusiasm are unquestioned, he was not above embellishing the facts. King measured the summit elevation at 14,386, more than 350 feet too high, but not a bad estimate using a barometer. His geological observations confirm he was an able scientist when glory didn't cloud his perceptions.

After descending Tyndall, the pair returned via an easier route and staggered into camp, to the relief of Brewer and the others. King tried to climb Whitney from the west later that summer but summitted Mount Langley by mistake. Nine years later, several Lone Pine residents became the first to climb the highest peak in the contiguous United States, reaching the 14,494-foot summit on August 18, 1873.

Below: *A small lake reflects the late afternoon sky and peaks above the South Fork of the Kings River.*

Right: *Hidetaka Suzuki cruises up the Valley classic Outer Limits.*

Following page: *Ferns abound in the shallow valleys of Giant Forest in Sequoia National Park.*

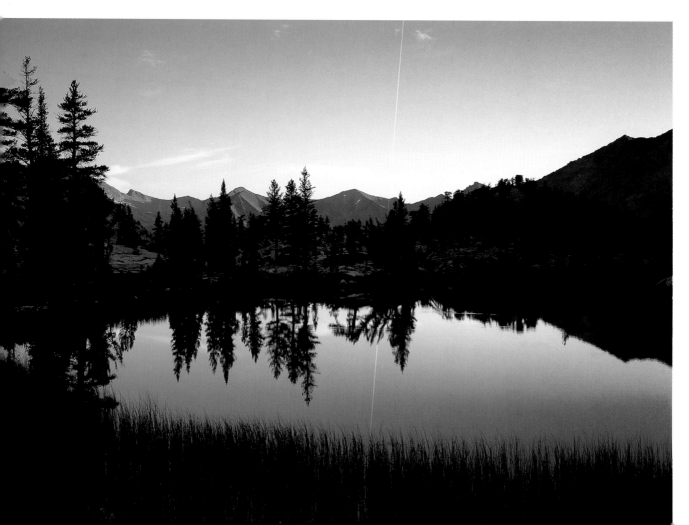

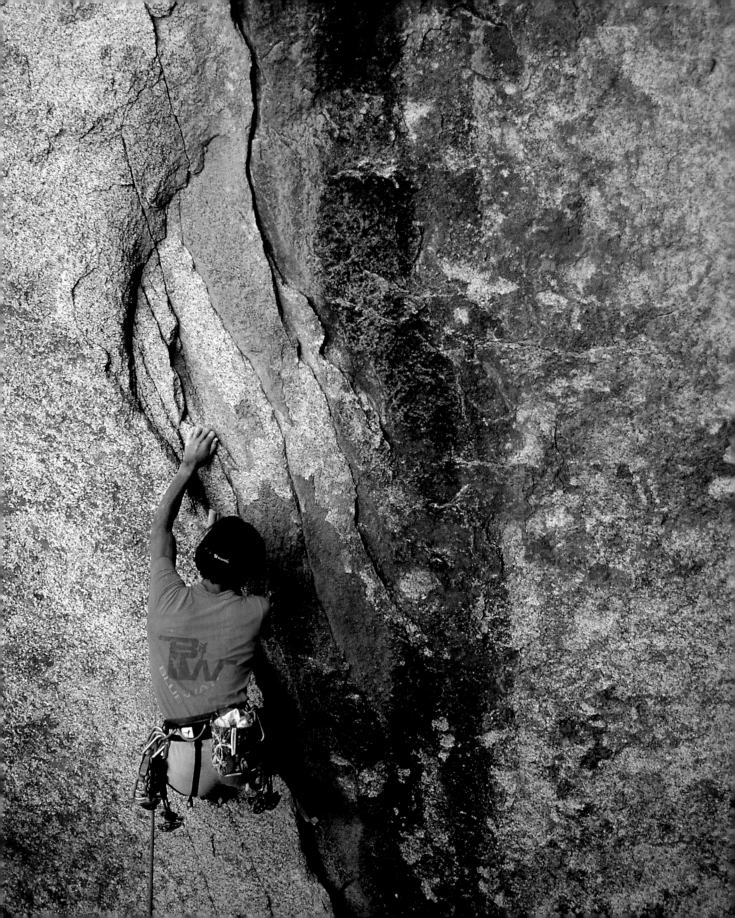

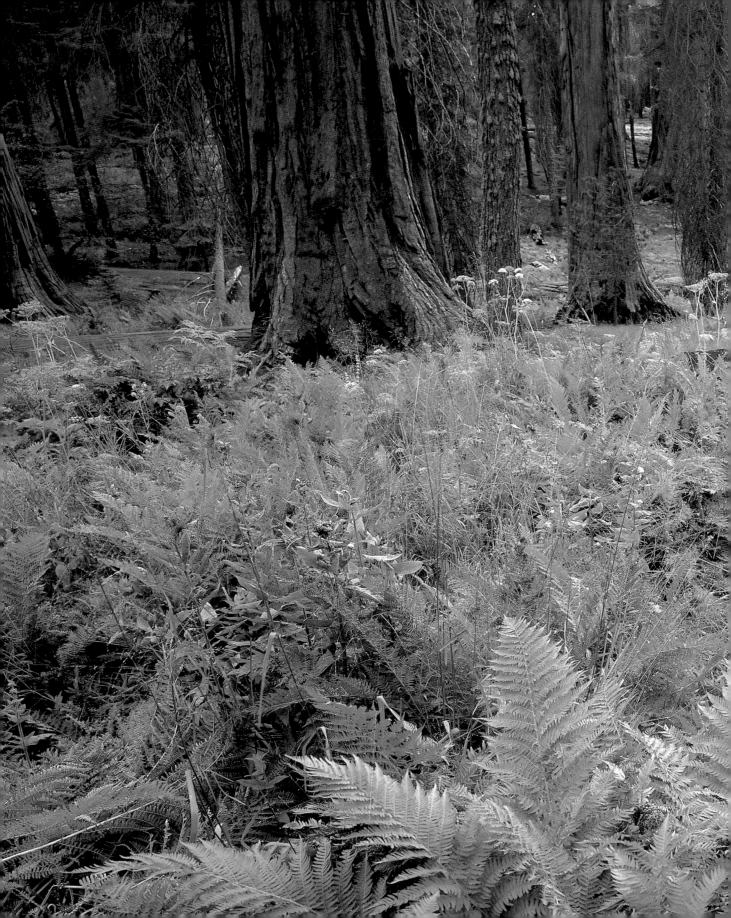

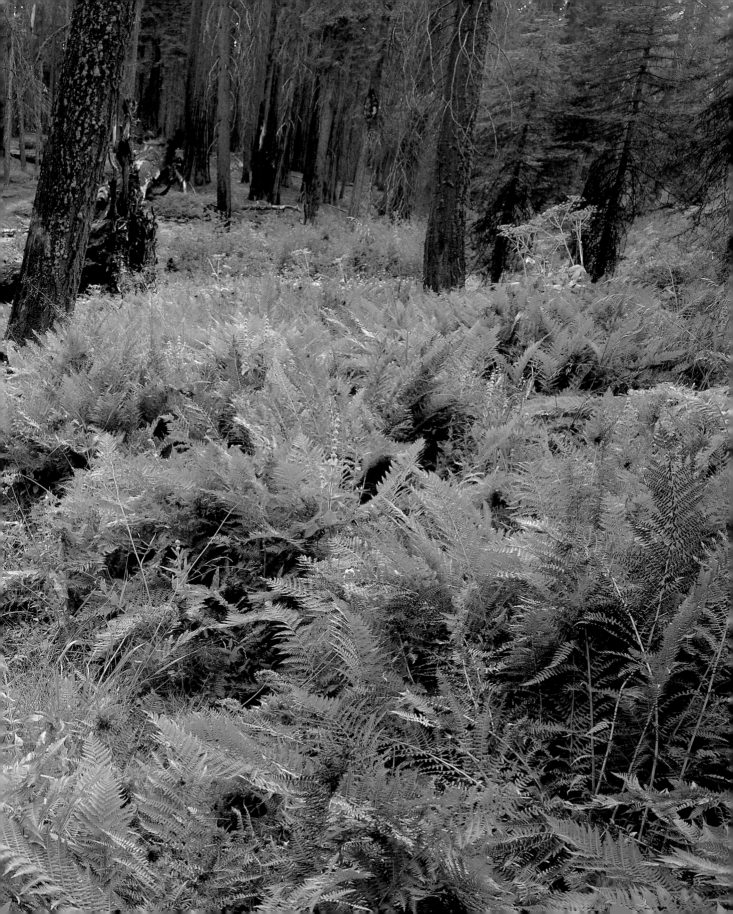

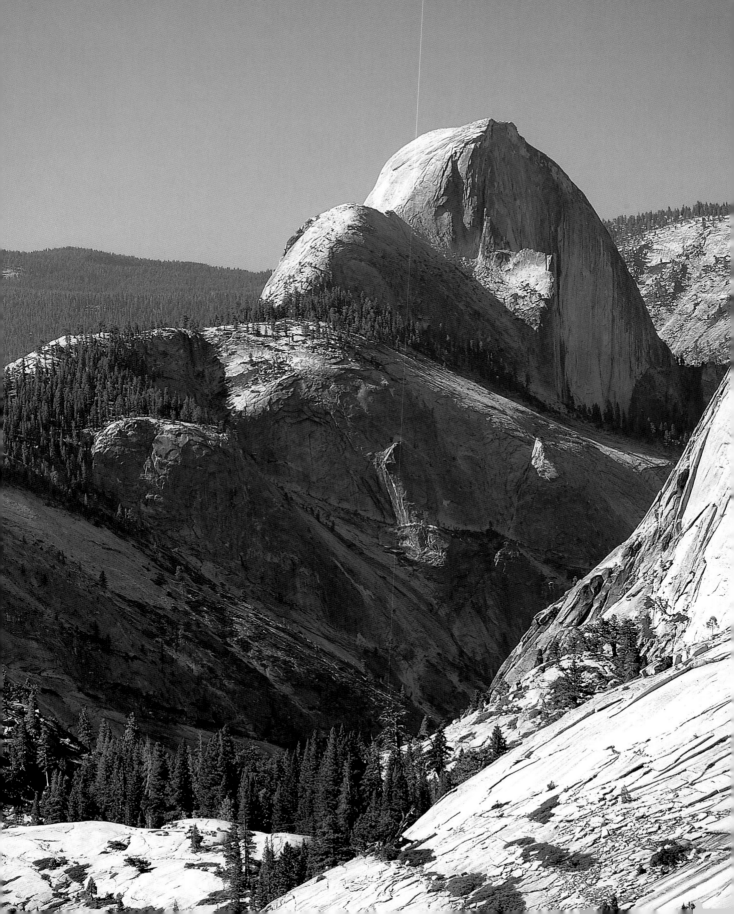

John Muir made an early attempt on Mount Whitney, but he duplicated King's error and found himself on Langley's summit, south of his goal. Undeterred, he hiked down to the Owens Valley and forged a route up the North Fork of Lone Pine Creek to Iceberg Lake. From the lake, Whitney's great eastern wall would have appeared unclimbable to anyone of Muir's generation. So he scrambled up a gully to a deep notch north of the summit and then picked his way up third-class ground to the top. His was the first ascent of Whitney from the east.

Both King and Muir explored but rarely climbed. Norman Clyde was the first and greatest true Sierra climber, obsessed with nabbing first ascents throughout the range. After moving to the Owens Valley east of the crest following the death of his wife, he devoted his summers and weekends to summitting unclimbed mountains. He already had a few first ascents to his credit, including a 1914 climb of Mount Electra (my first Sierra summit). Throughout the 1920s he accelerated his pace, amassing an incredible record of first ascents and new routes on previously climbed peaks. In 1925 alone he climbed forty-eight peaks, including twenty-four first ascents, almost all solo. The following year he summitted sixty peaks. He bagged the first ascents of the remaining unclimbed 14,000-foot mountains in the Sierra.

Where Muir traveled light, Clyde carried everything imaginable, including a cast iron skillet, an axe, and volumes of the classics in the original Greek. At a wiry 140 pounds, he carried from 75 to over 100 pounds. After losing his job as school principal of Independence for firing a .38 near a group of vandals, he spent the rest of his life guiding and acting as winter caretaker for high-country lodges.

Left: The glacier that filled the Tenaya Canyon stripped away the northwest side of Half Dome along the rock's vertical jointing.

In the 1950s Yosemite became the center of the rock climbing world. John Salathé, a Swiss blacksmith, crafted pitons (metal spikes) specially suited to the even-sided cracks in the Yosemite Valley walls. Salathé and Allen Steck climbed the 1,600-foot north wall of Sentinel Rock in 1950. Half Dome fell seven years later when Royal Robbins and his party found a route up its vertical face. The following year Warren Harding and others forced their way up the nose of El Capitan, developing techniques and equipment that would become big-wall basics. For example, Harding used sawed-off cast iron stove legs to protect a wide crack because no pitons were big enough to fit. Climbers exported methods perfected in Yosemite Valley to climb the

great walls of Alaska, Patagonia, and the Himalaya. Harding was the first to bring big wall techniques to the High Sierra with his ascents of Keeler Needle and the southwest face of Mount Conness.

The advent of bolts and other equipment had "murdered the impossible." Any face could now be climbed by mechanical means. In reaction, an ethos developed demanding that climbers climb free, bringing equipment only as safeguards employed in case of a fall. Proponents of this free-climbing style gravitated to the domes of Tuolumne, above Yosemite Valley. They balanced on tiny nubbins and pure slab, placing protection infrequently on the almost featureless granite. To this day classic Tuolumne routes are some of the scariest in the world.

Below: *Gaylor Lake glistens at timberline above Tuolumne Meadows with the Cathedral Range in the distance.*

Right: *Cathedral Peak and Fairview Dome from DAFF Dome, with erratics and dikes in the foreground.*

Following page: *Tuolumne Meadows partially floods during early season runoff.*

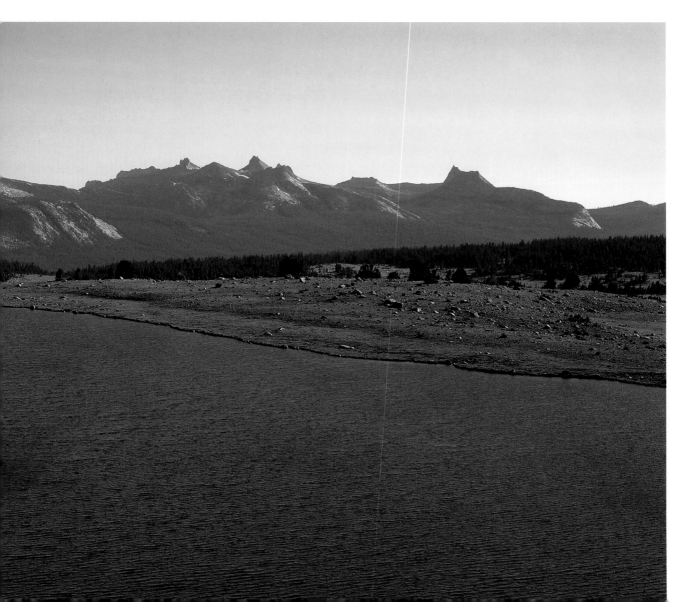

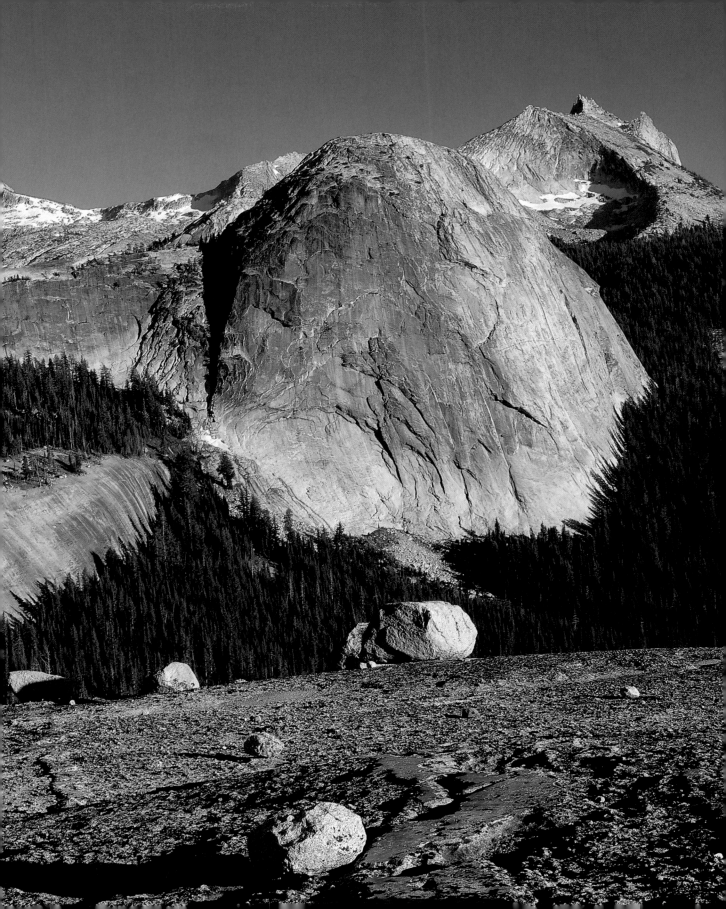

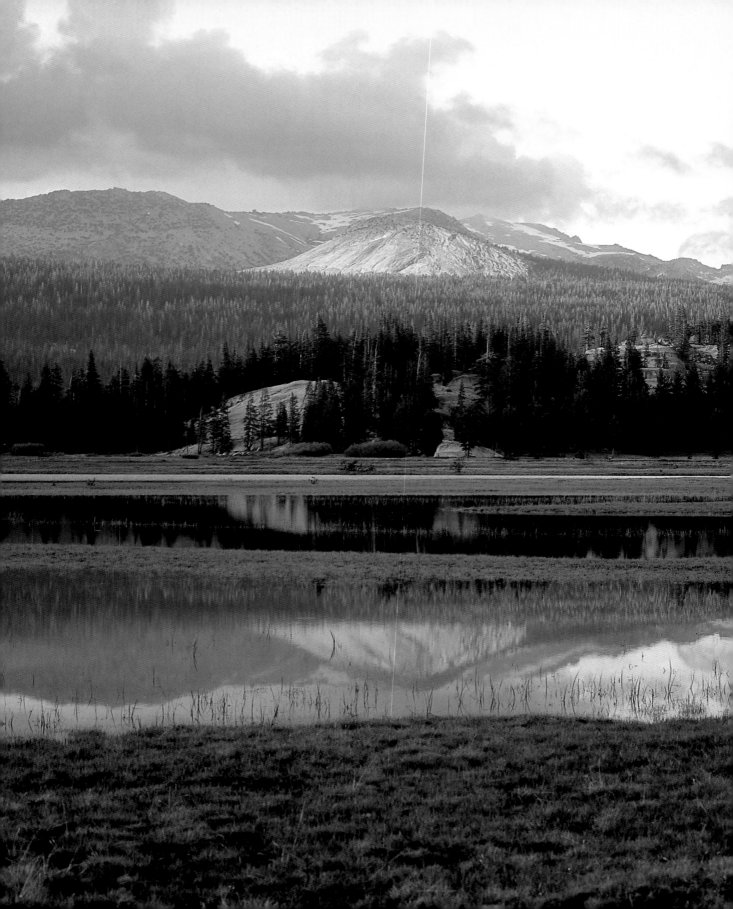

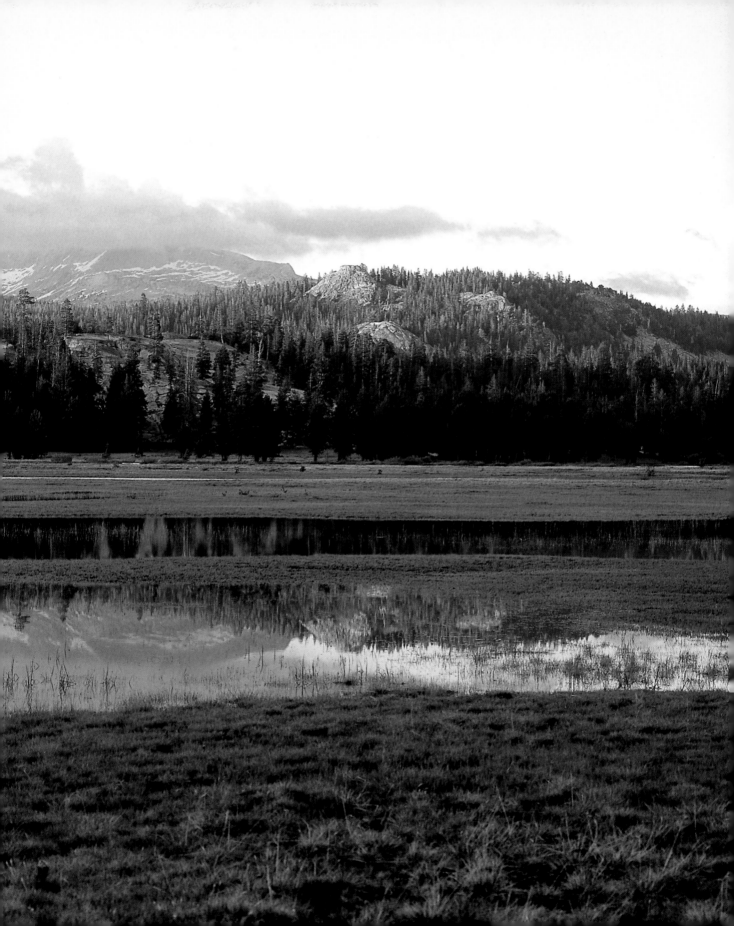

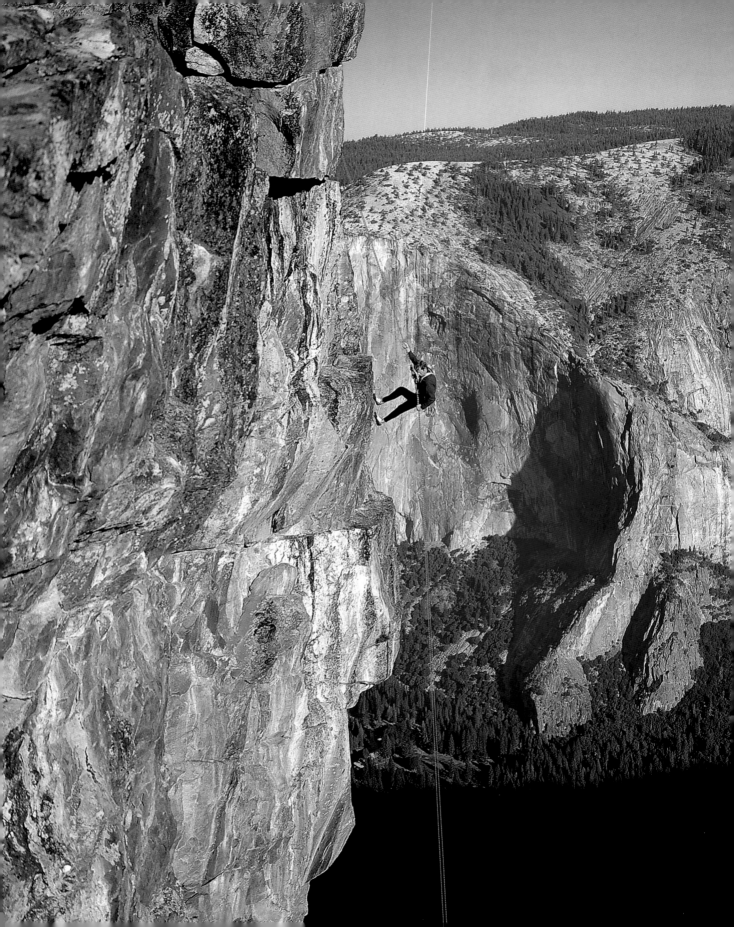

Despite the number of top-quality routes created by famous climbers, the High Sierra never gained the popularity of Grand Teton or Rocky Mountain National Parks. Most climbers would rather climb than hike, and Sierra routes require an approach hike of at least a day. The Sierra high country attracts connoisseurs of the wild and lonely, a rarity these days and worth cherishing.

No one put up more beautiful High Sierra routes in the last quarter-century than Galen Rowell. The celebrated photographer was famous in those days for his weekend sprints from the Bay Area to the east side of the Sierra. He trimmed travel time by employing hopped-up cars and aggressive driving. Once out of the car, he hiked quickly to his goal and dispatched his route with a professional's efficiency. Often he hiked back in the dark and drove most of the night to get to work Monday morning. Today his routes on Bear Creek Spire, Mount Humphreys, Charlotte Dome, Angel's Wings, and many more represent a tick list for the cognoscenti.

Although Yosemite was the cradle of big-wall climbing and ferocious crack routes, it later languished for years as sport climbing became popular. Sport climbs tend to be short, well protected, and gymnastic, consisting of face holds instead of cracks—whereas Yosemite is characterized by long, bold, strenuous cracks on smooth granite. But in the 1990s climbers brought the sport climbing ethos to Yosemite's big walls, and the free-climbing difficulty soared. Lynn Hill, once a Valley regular, returned after years on the sport climbing circuit to free-climb the 3,000-foot Salathe Wall on El Capitan. Her ascent was a stunning, and for years unrepeated, achievement. After her landmark climb, the world's best climbers converged on Yosemite again to set ever higher standards.

Despite the unflagging efforts of generations of climbers, the Sierra still bristles with new challenges. Seldom-seen ribs of clean rock await their first suitors, and untouched granite faces abound. While most of the classic lines have seen at least one ascent, an infinite array of moderate lines and hyper-difficult problems remain to tempt new generations in the wild backcountry of the Range of Light.

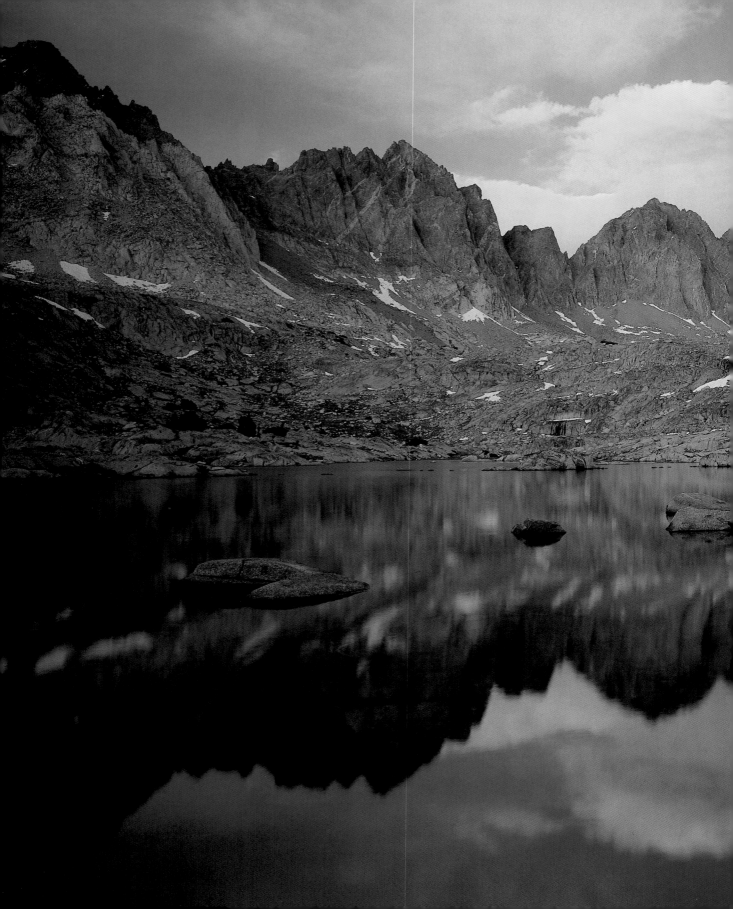

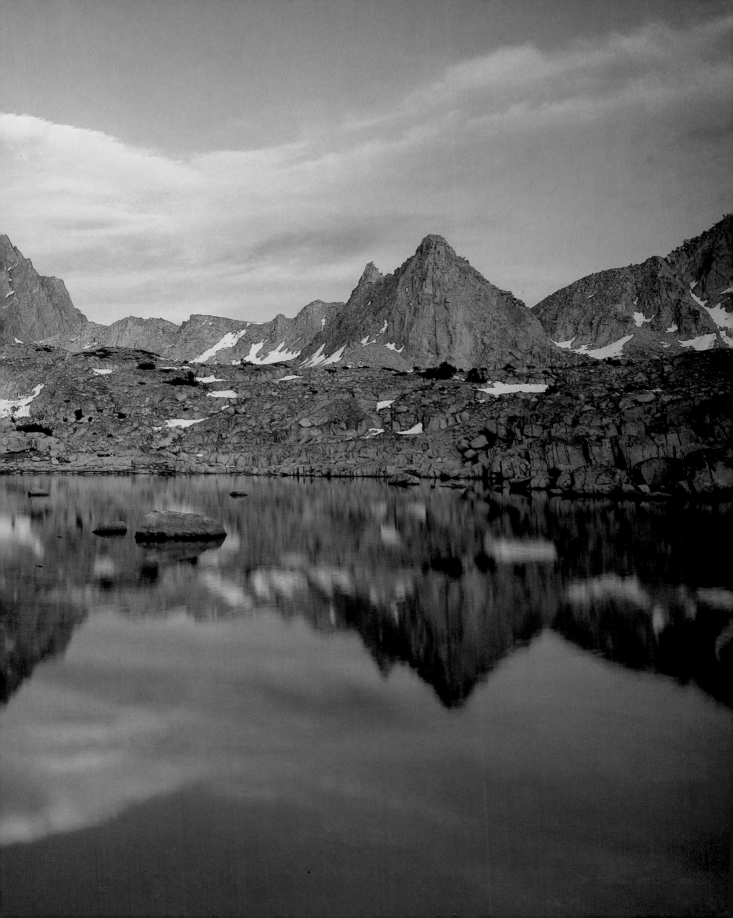

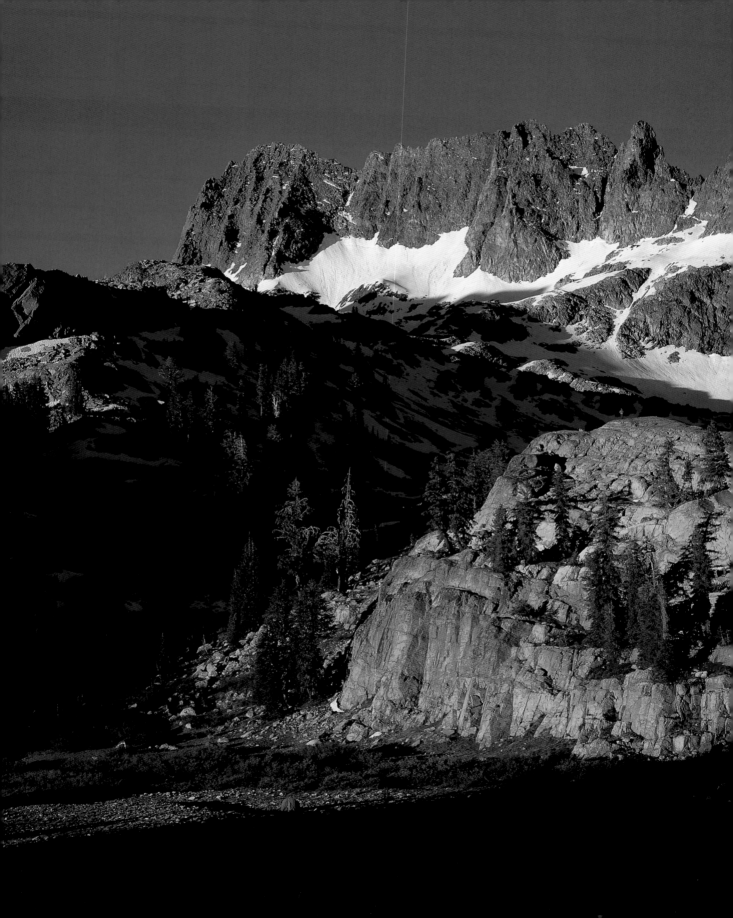

Photography Notes

Toward the end of my senior year at Los Gatos High School, I ducked out of class early on spring weekends to hitchhike 250 miles to Yosemite Valley. I walked the trails and wandered cross-country to unique views, usually solo. When I was lucky, I'd come across Ansel Adams teaching photography to a small group. I would hang back and try to glean his secrets, but usually he discoursed on the subtleties of the Zone Technique, arcana that meant nothing to me at the time. When he talked about composition, I could follow, and I tried to adapt his lessons on my Instamatic. He noticed the shy kid in the shadows and gave me a friendly nod instead of shooing me away.

With that scant encouragement, I embarked on a casual study of landscape photography. At first I sought pretty pictures. Later, I tried to create them. While one can get lucky in the field, visualizing the finished image in advance enhances the chance for success. On a trip to Africa I saw Art Wolfe sketching the images he wanted to create with his camera. Thereafter I tried to do the same thing, and my photography improved at once.

While equipment isn't the most important element in photography, it contributes to the finished product. I shot most of the images in this book with a Mamiya 7 6x7cm rangefinder camera and three lenses: 43mm wide angle, 80mm normal, and 150mm telephoto. These correspond to 21mm, 40mm, and 75mm focal lengths in a 35mm camera.

The Mamiya 7 delivers irresistible advantages. First, the glass is the highest quality available, yielding exceedingly sharp images. Second, rangefinders tend to be sharper than single-lens reflex cameras. Third, a medium-format transparency is many times larger than a 35mm slide, so grain isn't multiplied as much in enlargements. Finally, the Mamiya 7 is light and compact. Rangefinder lenses are smaller than equivalent single-lens reflex lenses. The body of the camera weighs less because it requires no mirror assembly for focusing, and the absence of mirror movement reduces vibration. The 7 employs leaf shutters in the lenses instead of a focal plane shutter next to the film. This saves weight and reduces vibration so a lighter tripod and ballhead will suffice. I use the lightest carbon fiber Gitzo tripod and the smallest Kaiser ballhead when backpacking with the 7.

But rangefinders giveth and rangefinders taketh away. Since neither focusing nor metering occurs directly through the lens, operating the camera demands more deliberation. Determining depth of field becomes a matter of mathematics or experience. You can't see what the lens sees. (Each lens has a depth of field scale but it can serve only as a rough guide.) The light meter doesn't take filters into account, so you must know each filter factor or hold it up to the meter before use. This is critical for polarizers because they subtract between one and two stops depending on the angle of the light and the rotations of the filter.

Landscape photographers depend on graduated neutral density filters. Slide film suffers from a restricted dynamic range, which is another way of saying that it exaggerates contrast. The difference between black and white is only five stops on the aperture scale. At sunset, for example, the sky may be five stops brighter than the foreground. If you expose for the sky, the foreground will turn black. If you expose for the foreground, the sky will

Right: *Polemonium, also known as Sky Pilot, prefers rocky crevices on the high peaks, such as the summit plateau of Mount Whitney.*

Following page: *Glaciers on either side of Yosemite's Matthes Crest ground the ridge to a knife-edged fin. The Merced Range is in the distance.*

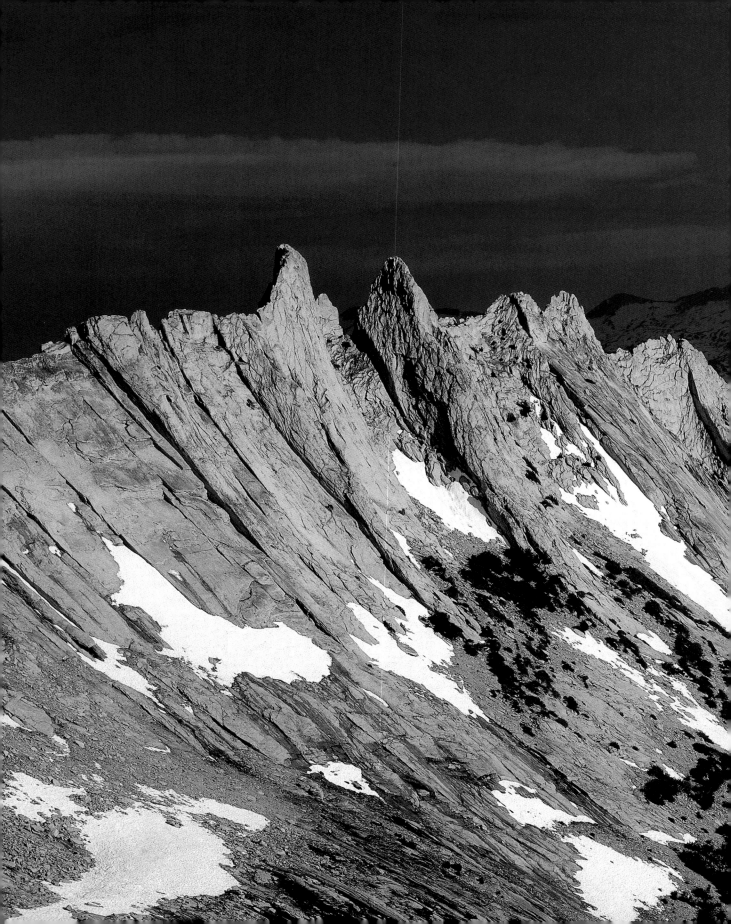

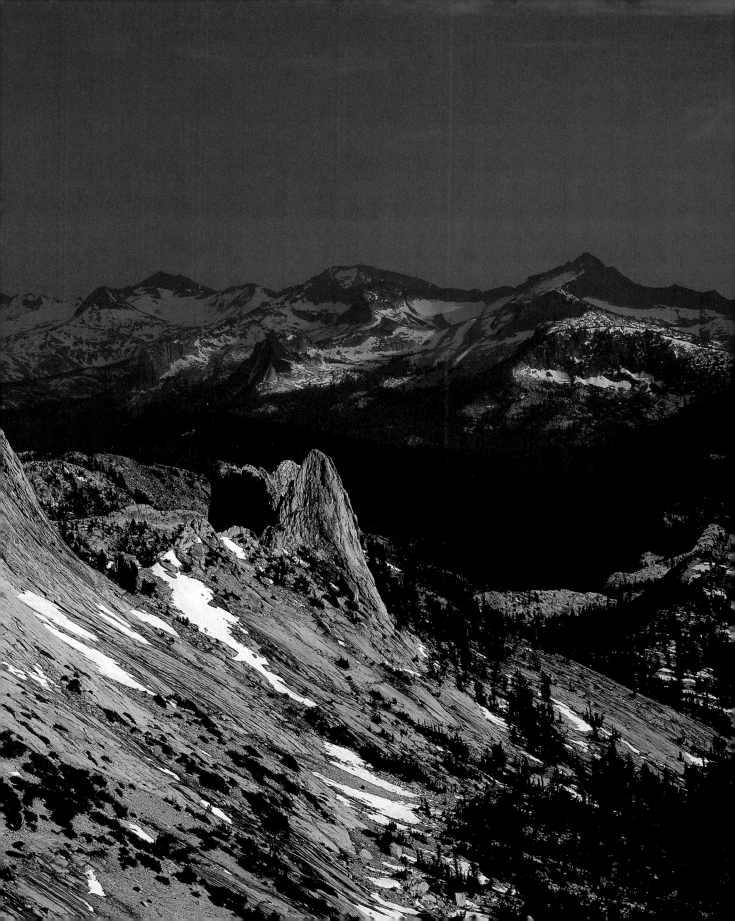

turn white. A graduated neutral density filter is half clear and half gray. The gray will subtract one, two, or three stops (depending on the filter) without affecting the color. The trick is to place the transition in the right place so it doesn't show on the image. This is easy on a single-lens reflex: You can see the effect of the filter through the viewfinder. With a rangefinder camera, you must guess. When I am not sure I can place the transition perfectly, I take several shots, repositioning the filter slightly each time to ensure that at least one image will be just right.

The final filter in my kit is an 81b warming filter. On clear days shadows pick up a blue cast from the sky. The warming filter shifts the color back to neutral tones. It can also warm a dull sunset or drab rock face, but modern saturated films pump up color enough for my taste.

Using a rangefinder forces me to slow down and work deliberately. Often when I'm fussing with the equipment or double-checking my calculations, I notice a distracting element in the frame or recognize a better composition a few feet to one side. Sometimes it takes a while for the composition that speaks to me to take shape in my mind.

The limited range of lenses forces me to use a 35mm camera sometimes. There is no macro capability with the Mamiya 7 (Mamiya makes a macro adapter, but its magnifications are minimal), so I use a Canon system for flower close-ups and the like. I find the Mamiya 150 telephoto inadequate for shooting climbers on a cliff or for isolating a distant composition embedded in an otherwise uninteresting scene. Here again, I go to my Canon lenses with focal lengths ranging from 70mm to 500mm.

Fuji Velvia serves as my workhorse film. Velvia is slow, rated at ISO 50 but usually shot at 40. It is a high-contrast film, so shooting with harsh shadows in the frame will ruin most photographs. Even so, most other films look grainy in comparison. The saturation is ideal for landscapes. The former industry standard, Kodachrome 64, looks gray in comparison.

Right: *Looking west from Dusy Basin in Kings Canyon National Park.*

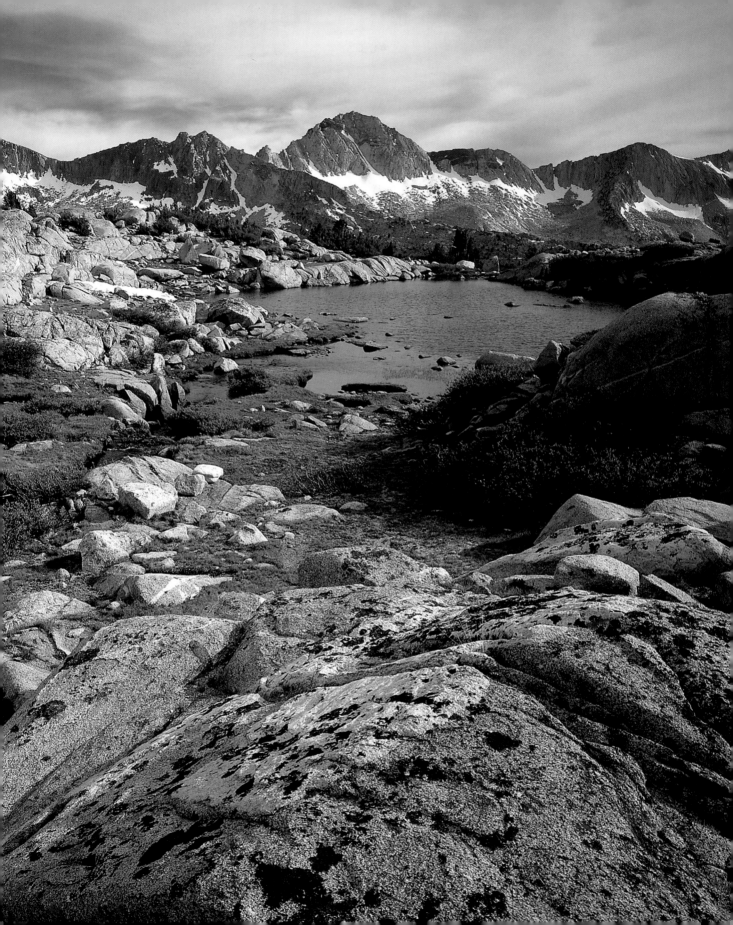

Bibliography

Clyde, Norman. *Close-ups of the High Sierra*. 1st ed. Edited by Wynne Benti. Bishop, CA: Spotted Dog Press, 1998.

Gilligan, David. *The Secret Sierra: The Alpine World Above the Trees*. 1st ed. Bishop, CA: Spotted Dog Press, 2000.

Hill, Mary. *Geology of the Sierra Nevada*. Maps by Adrienne E. Morgan; drawings by Alex Eng and others. Berkeley: University of California Press, 1975.

Jassby, Alan, et al. "Atmospheric deposition of nitrogen and phosphorus in the annual nutrient load of Lake Tahoe." *Water Resources Research* 30, no. 7 (July 1994): 2207-2216.

Jones, Chris. *Climbing in North America*. Seattle: Mountaineers Books, 1997.

Kerouac, Jack. *The Dharma Bums*. New York: Penguin Books, 1990.

King, Clarence. *Mountaineering in the Sierra Nevada*. Edited and Preface by Francis P. Farquhar. Lincoln, NE: University of Nebraska Press, 1997.

Matthes, Francois E. *The Incomparable Valley*. Edited by Fritiof Fryxell. Berkeley: University of California Press, 1950.

McPhee, John. *Assembling California*. 1st ed. New York: Farrar, Straus & Giroux, 1993.

Moore, James G. *Exploring the Highest Sierra*. Stanford, CA: Stanford University Press, 2000.

Muir, John. *John of the Mountains: The Unpublished Journals of John Muir*. Edited by Linnie Marsh Wolfe. Madison, WI: University of Wisconsin Press, 1979.

————. *The Mountains of California*. New York: Penguin USA, 1997.

————. *My First Summer in the Sierra*. Introduction by Galen Rowell. Boston: Houghton Mifflin Company, 1998.

————. *Our National Parks*. Washington, D.C.: Ross and Perry, Inc., 2001.

————. *Yosemite*. Introduction and Photographs by Galen Rowell. Yosemite, CA: Yosemite Association, 2001.

Rowell, Galen, Ed. *The Vertical World of Yosemite*. Berkeley: Wilderness Press, 1974.

Snyder, Gary. *The Practice of the Wild*. San Francisco: North Point Press, 1990.

————. *Riprap and Cold Mountain Poems*. San Francisco: North Point Press, 1990.

————. *Six Sections from Mountains and Rivers Without End*. San Francisco: Four Seasons Foundation, 1970.

Acknowledgments

Thanks to Fred Ramsing for alerting me to one probable cause of water degradation in the Sierra. I appreciate the indulgence of my hiking partners who put up with my demanding itineraries. Peter Potterfield, Alison Braun, Carl Cook, Bart Smith, and Roger DeCamp, the Mighty Bear, deserve special mention. Without my wife Terrie's encouragement and support for the past twenty-five years, this book would not have come into being and my life would have been arid, pointless, and dull.

Park Information

Yosemite National Park
P. O. Box 577
Yosemite National Park, CA 95389
(209) 372-0200
www.nps.gov/yose/

Mono Basin National Forest Scenic Area
Inyo National Forest
P. O. Box 429
Lee Vining, CA 93541
(760) 647-3044
www.r5.fs.fed.us/inyo/vvc/mono/

Mammoth Lakes Visitor Center
Inyo National Forest
P. O. Box 148
Mammoth Lakes, CA 93546
(760) 924-5500
www.r5.fs.fed.us/inyo/vvc/mammoth/

Sequoia & Kings Canyon National Parks
47050 Generals Highway
Three Rivers, CA 93271-9651
(559) 565-3341
www.nps.gov/seki/

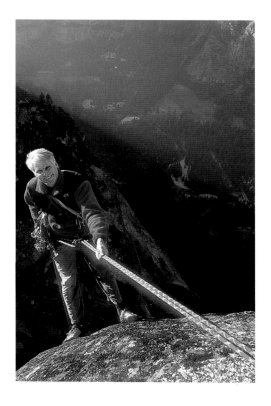

James Martin

In the last twenty years, photographer Jim Martin has climbed in Africa; crossed South Georgia Island; learned how to take photographs from Art Wolfe; beat cancer; had a wild orangutan crawl into his arms; watched an orca swim twenty feet below him; written ten children's books, as well as the first scientific work on chameleons; hiked with Gary Snyder and climbed with Jon Krakauer; and petted a wild Komodo dragon. "My life has no thread to it," Martin explains, "except the stubborn determination to do what I want." He has been exclusively a photographer and writer since 1989, publishing in magazines including *Smithsonian*, *Outside*, *Climbing*, *Sports Illustrated*, *Backpacker*, and *Seattle Times' Pacific*; recent books include *North Cascades Crest* (Sasquatch Books) and the award-winning *Extreme Alpinism* (Mountaineers Books) co-authored with Mark Twight. He has also been climbing and exploring the Cascades for more than ten years and photographing his trips, often with pioneer alpinists such as Fred Beckey and Jim Nelson. "I want to show people a side of familiar areas that is unfamiliar," he says. Martin lives in Seattle, Washington.